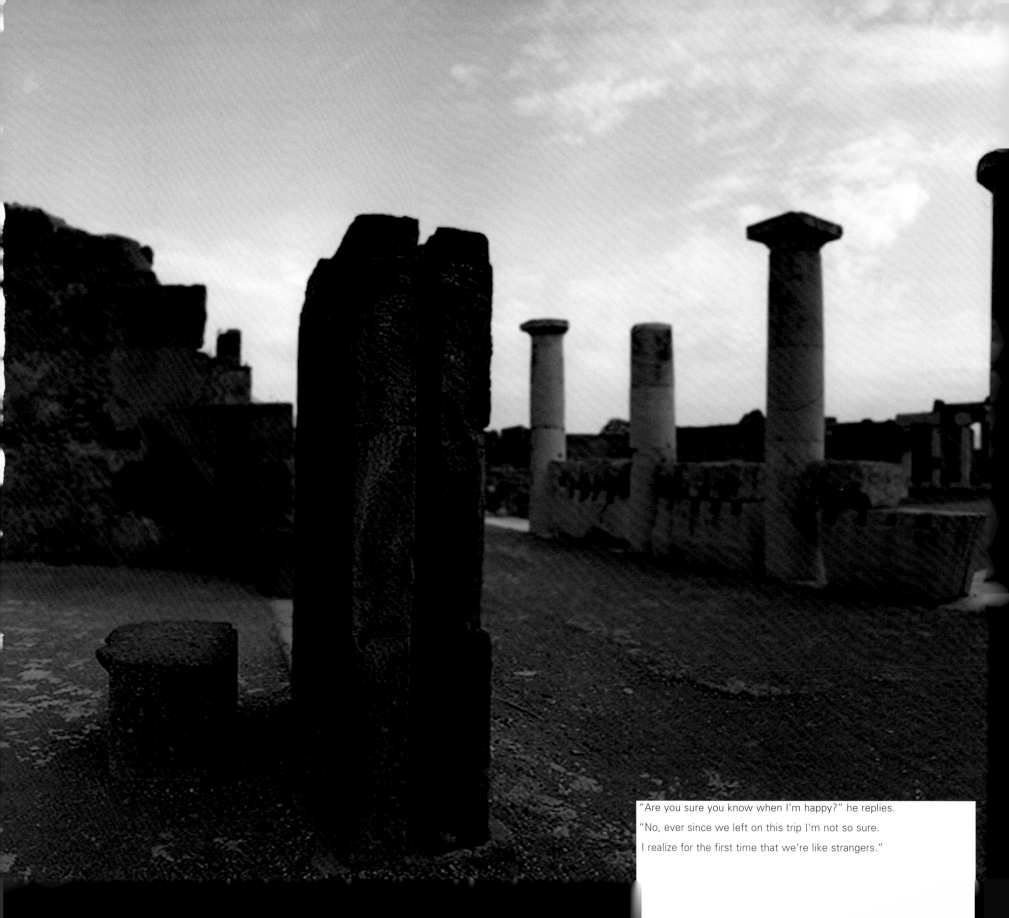

"Are you sure you know when I'm happy?" he replies.

"No, ever since we left on this trip I'm not so sure.

I realize for the first time that we're like strangers."

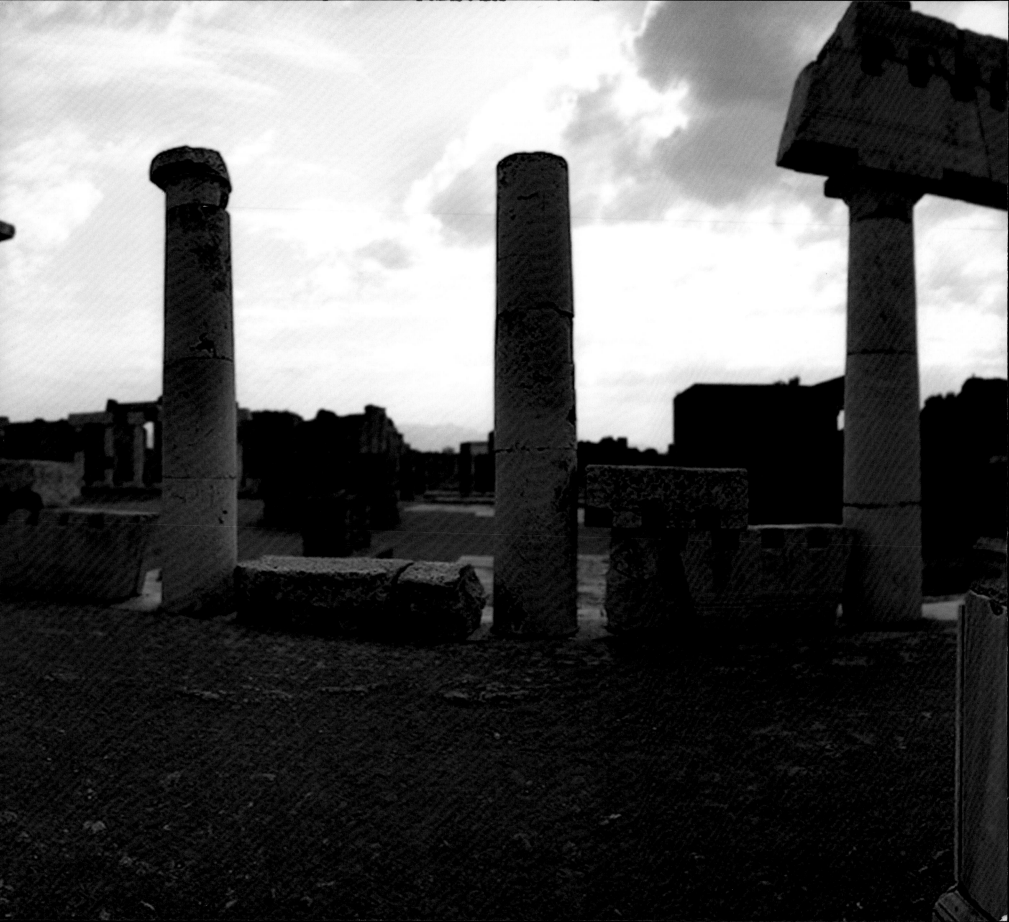

# VICTOR BURGIN
# VOYAGE TO ITALY

*Voyage to Italy* (2006)
Single screen digital video projection with sound
Dimensions variable

# VOYAGE TO ITALY

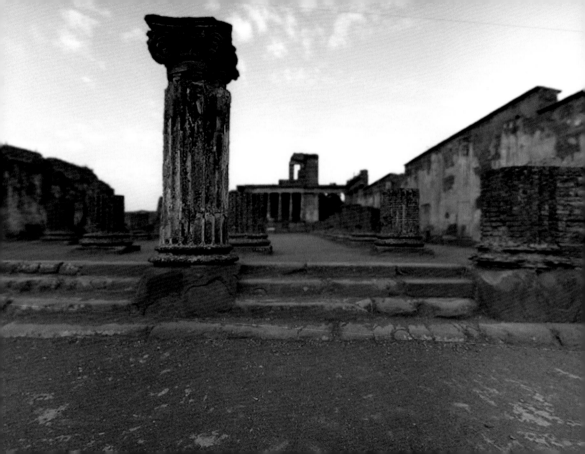

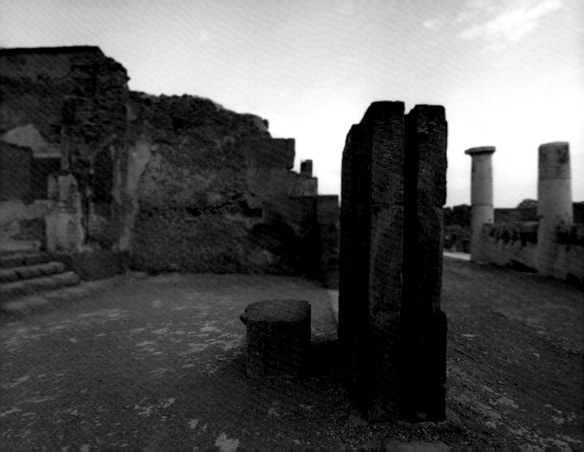

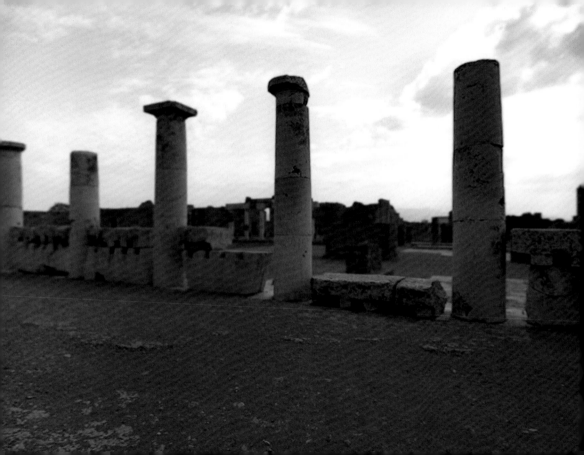

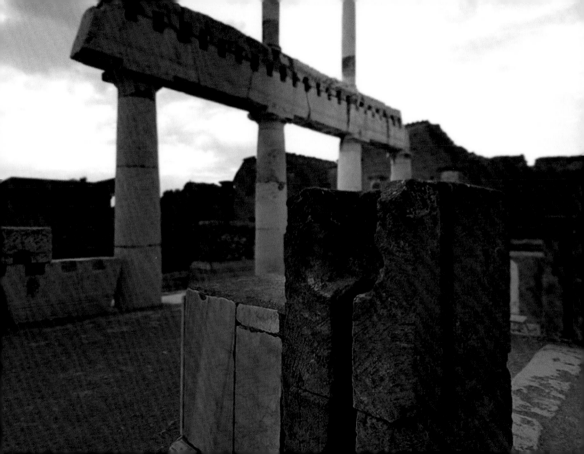

p on the shoulder of the road, and slides over to
out and walks around to sit in the driver's seat.
 steers the car back onto the road.

ne," he says, "we wouldn't be wasting our time
een back home a week ago."
 it would be so boring for you to be alone with me,"

They are driving from Pompeii, where they watched
a cavity in the compacted volcanic ash: a man and a
at the moment of death.

 summer sky. Across flat fields a perspective of
es fast and wheels past the speeding car.
cession.

In tears she turns and moves away. He follows her p
faded murals and parched pools; past what was buri
now exhumed, exposed and shelterless.

ou're very happy when we're alone."
when I'm happy?" he replies.
 this trip I'm not so sure. I realise for the first time

He says: "I understand how you feel."
"I thought we had agreed we don't know each othe
"What game are you playing? What is it you want?"
"Nothing. I despise you."

 in the road at which a tall crucifix stands near an
 of a giant bottle. An avenue of evenly spaced trees
 car follows the curve to the left, where the road

Not speaking they walk side-by-side past broken am

ere are we?"

," she replies.

ve?"

tired."

ugh the fields a freight train sounds its whistle.
 summer sky. A perspective of telegraph poles
els past the speeding car. Milestones glide by

lways seemed to have something to talk about, but
 different country . . ."

"It seems we have nothing to say to each other."

ahead is a small cart pulled at a brisk trot by a
t, a woman beside him. Some way behind the cart
ggles across the road.

ow you feel."

had nothing to say to each other," she replies.

ing? What is it you want?"

She says: "I'm sorry I spoke to you that way."

"Why? Our situation is quite clear. There is nothing
to apologize."

"Now who's playing games? What's the point?"

They drive on between monotonous trees. A car ap
opposite direction, covered in dust, its roof laden wi
secured with strings and ropes. Behind it a stragglin
push and pull belongings heaped in handcarts and p
passing a convoy of drab green lorries, filled with st
sitting with their rifles between their knees. The roa
vehicles and the air is black with smoke.

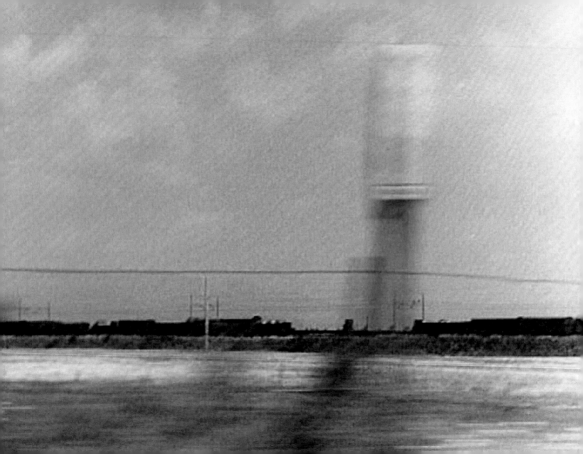

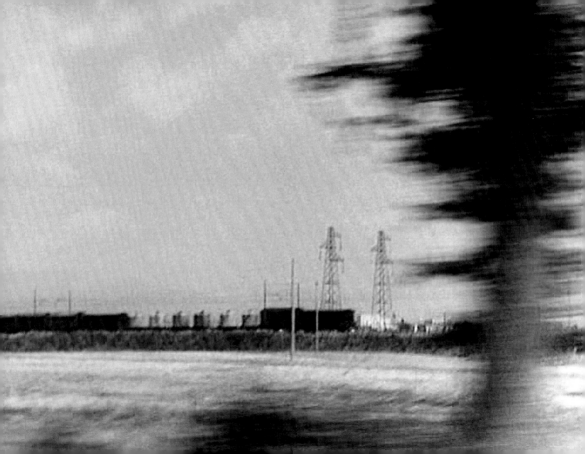

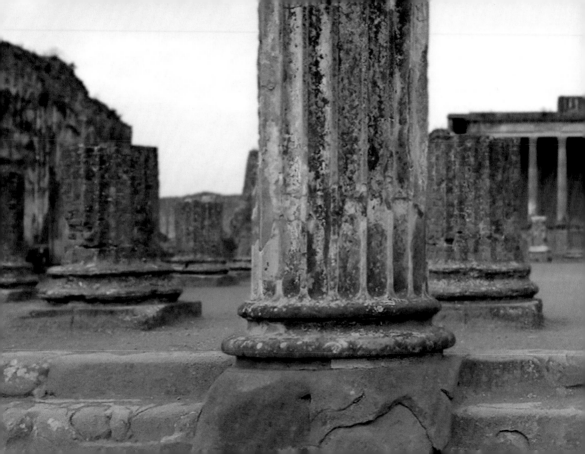

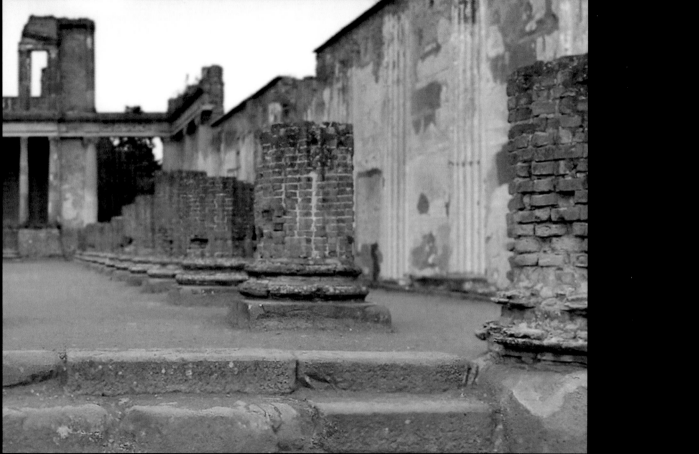

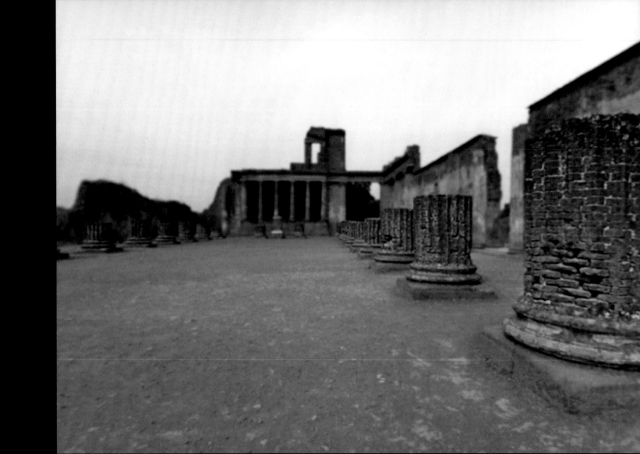

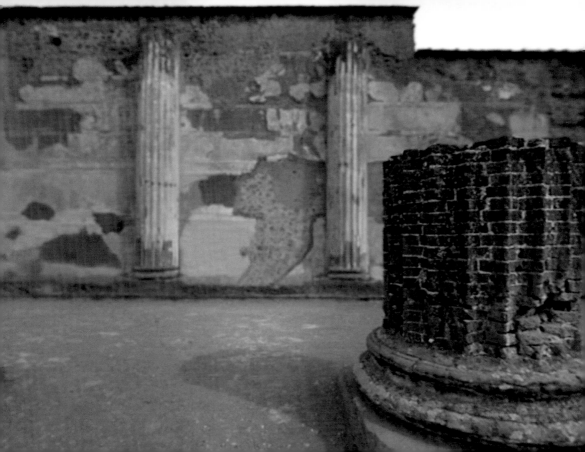

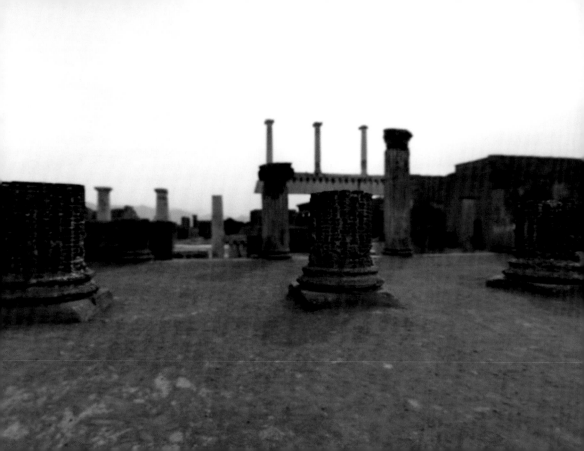

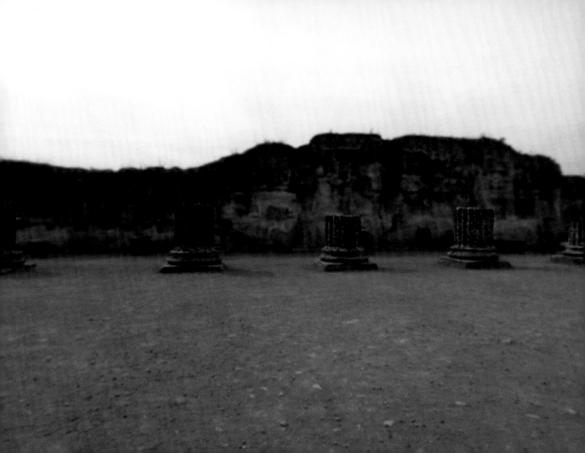

*Basilica I* (2006)
24 black and white photographs in superposed horizontal rows of 12, and one text
Each image 12 x 8 cm. Each frame 30 x 20 cm
Overall dimensions 66 x 332 cm.

BASILICA I

Four wide stone steps lead from the Forum to the Basilica. Rising from these are four columns. The capitals are Pompeian Ionic, their volutes embellished with palmettes curling back to the abacus. In plan the Basilica is a columnar nave surrounded by an aisle. There are twelve Corinthian columns on each long side of the nave, and an engaged Ionic order along the walls that flank the aisle. At the far end of the nave is a raised tribunal with six Corinthian columns. In this ruined and deserted place the solitary figure of a woman stands, shrouded in a voluminous cape over a wide crinoline skirt, her face hidden in the shadow of a broad brimmed hat.

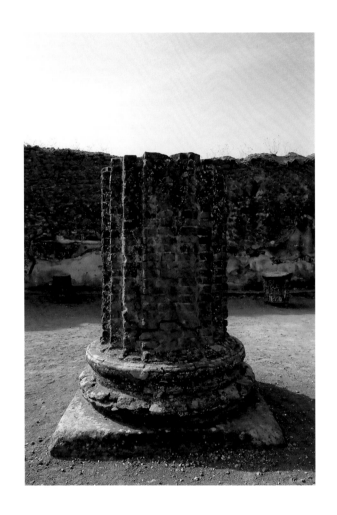

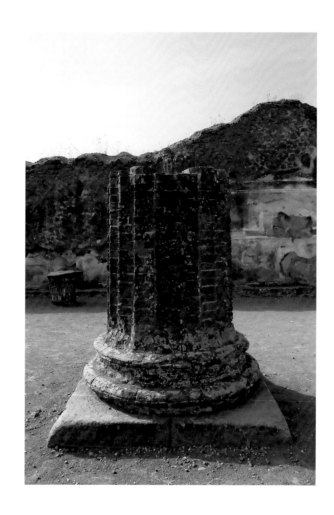

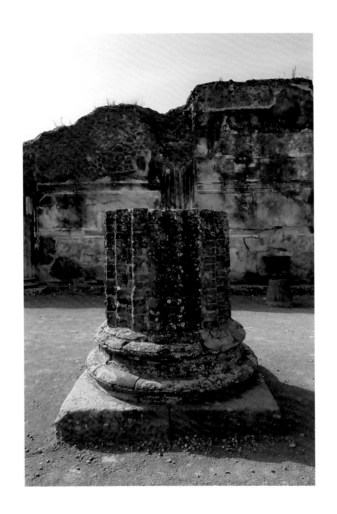

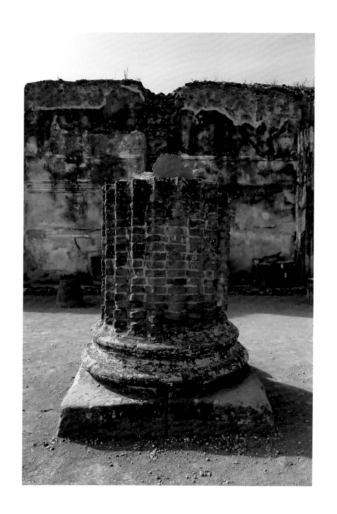

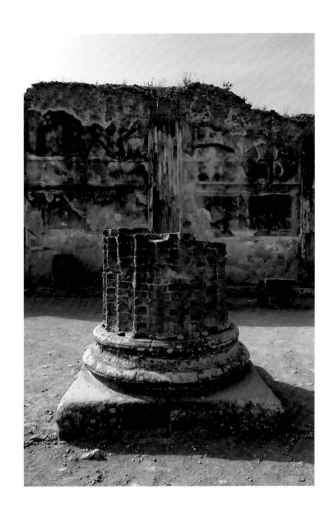

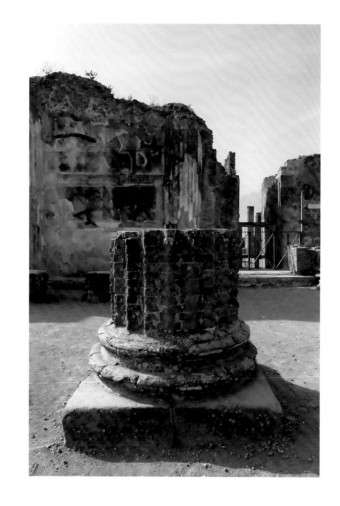

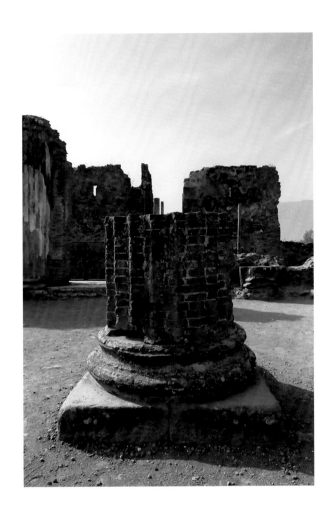

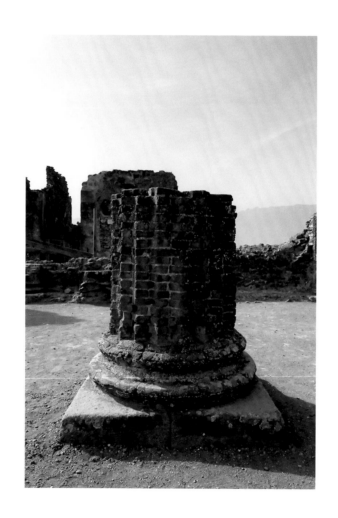

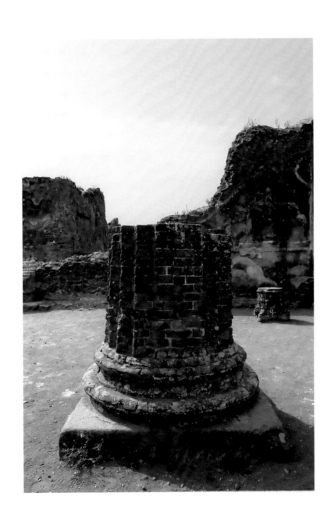

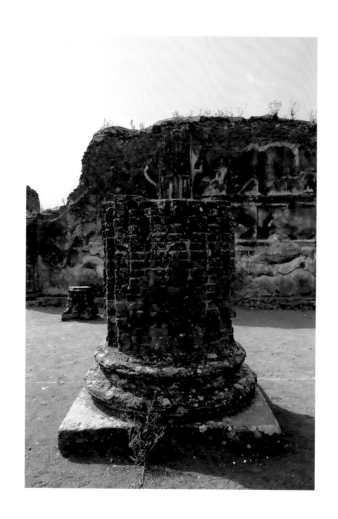

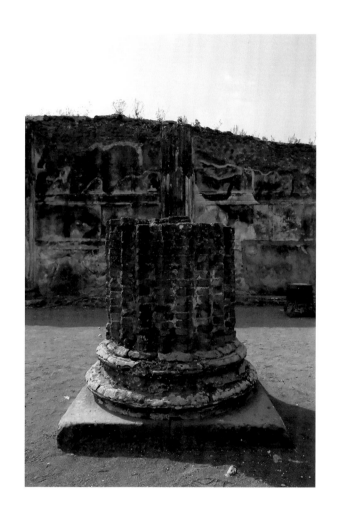

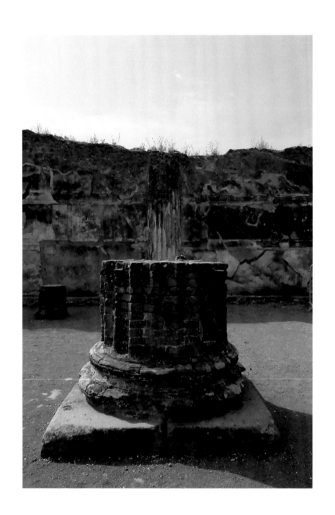

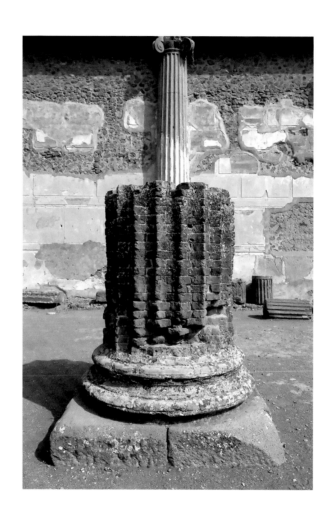

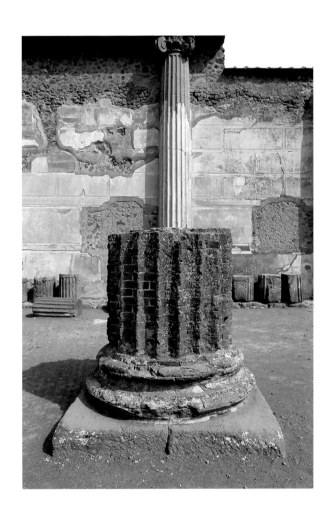

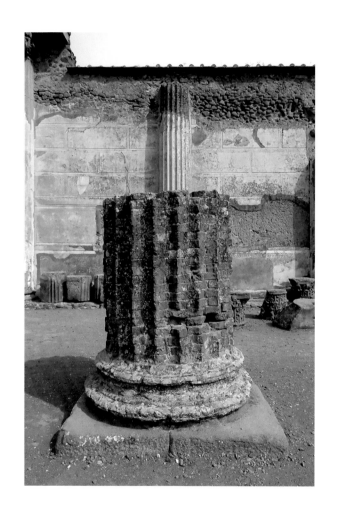

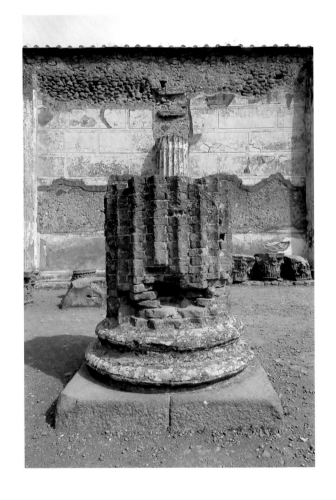

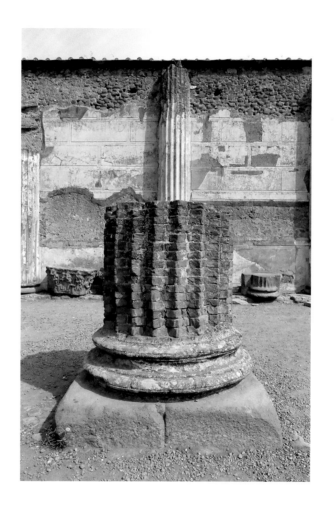

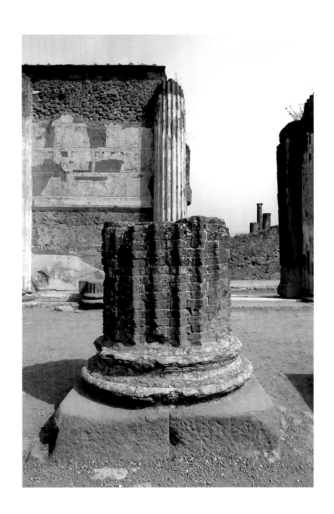

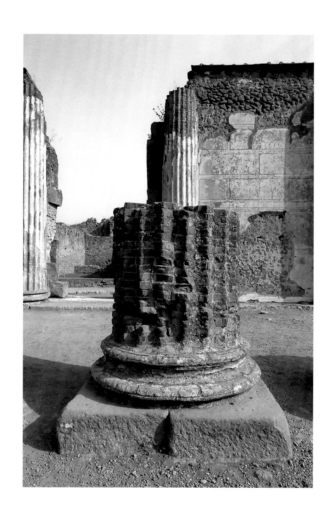

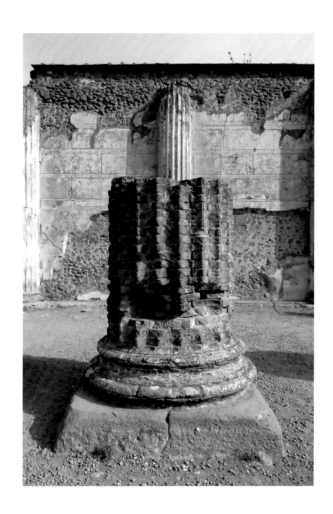

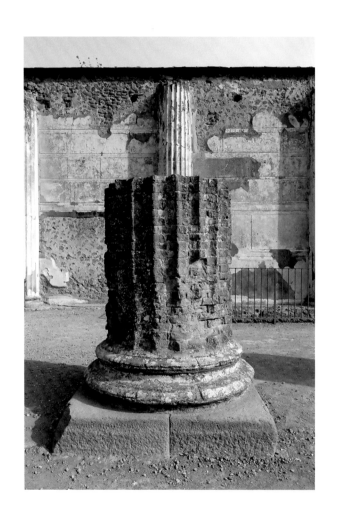

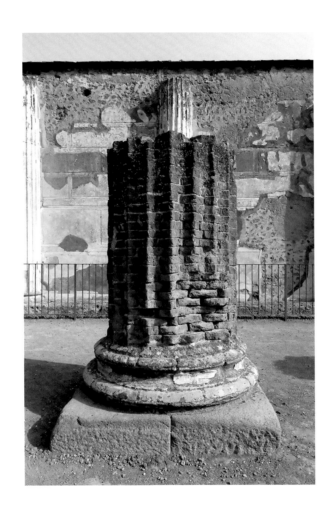

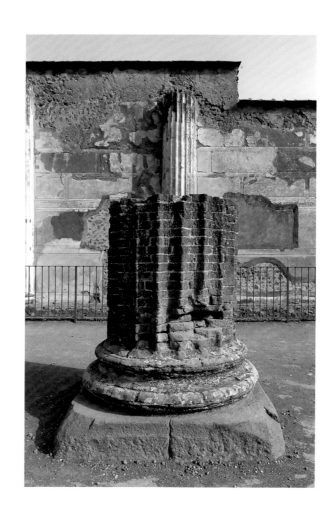

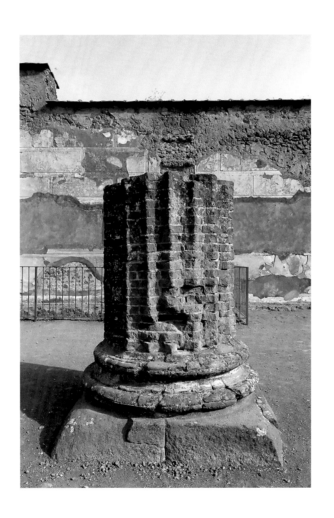

*Basilica II* (2006)
17 black and white photographs in superposed horizontal rows of 9, and 8 with one text
Each image 15 x 10 cm. Each frame 39 x 26 cm
Overall dimensions 86 x 298 cm

# BASILICA II

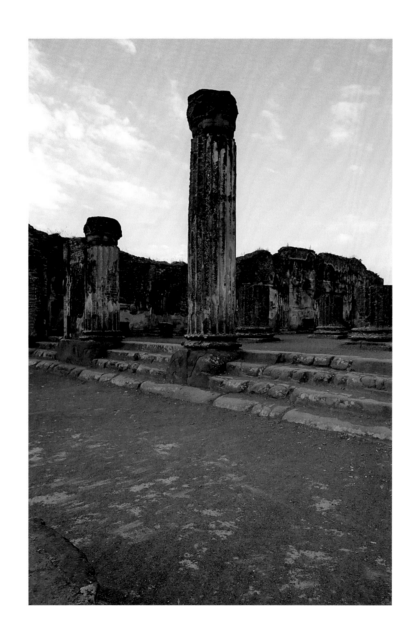

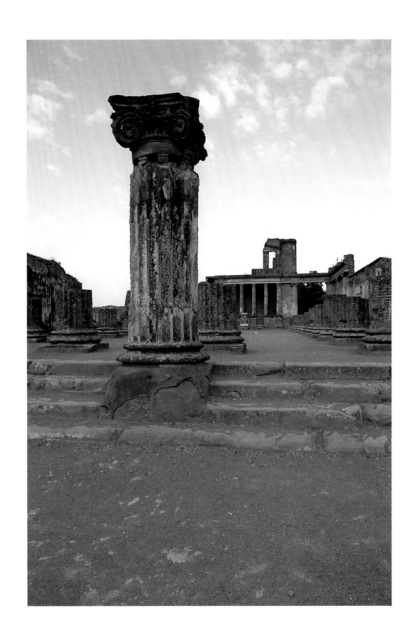

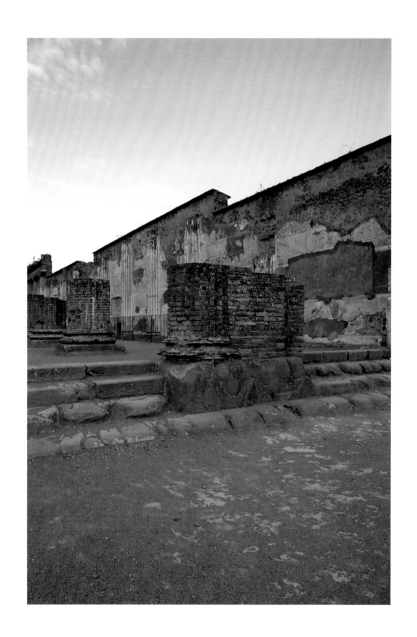

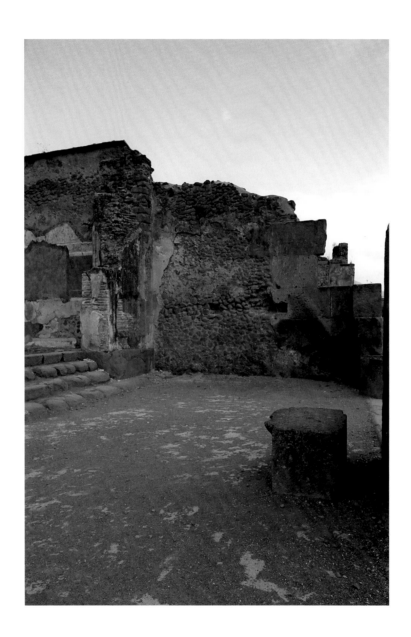

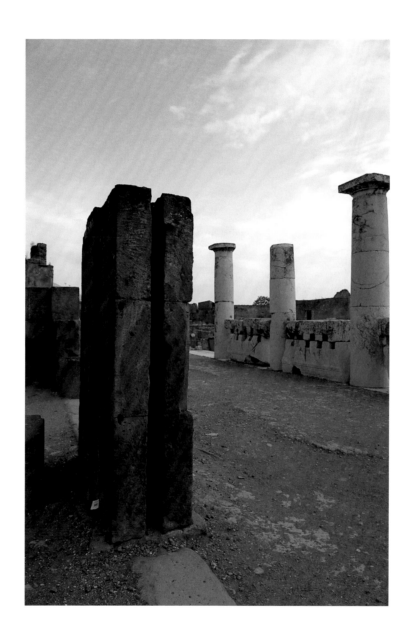

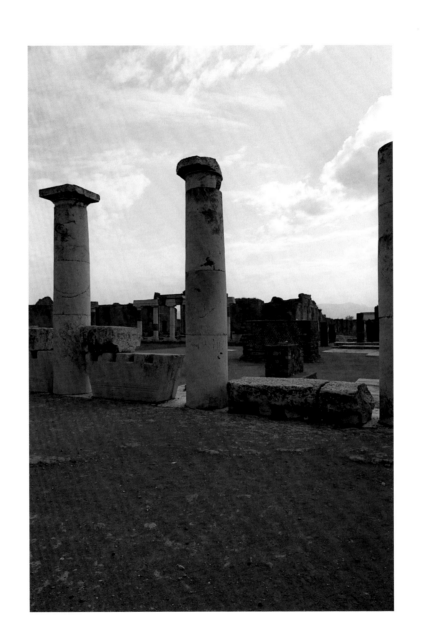

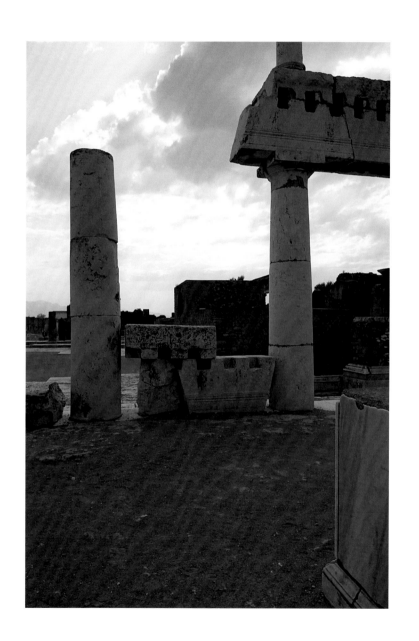

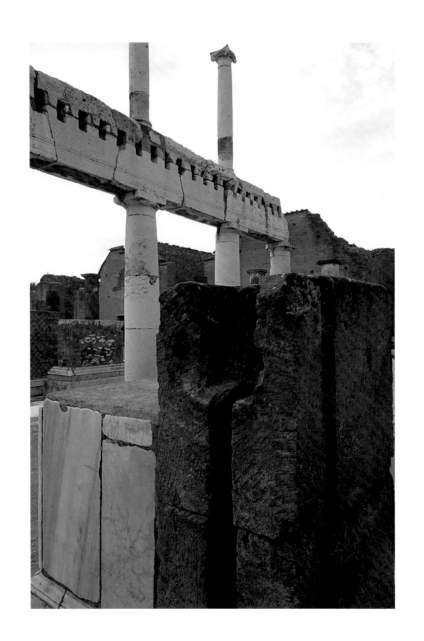

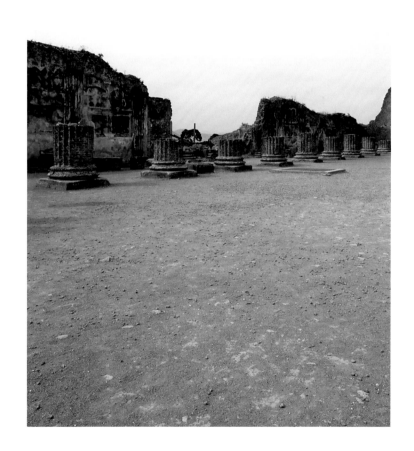

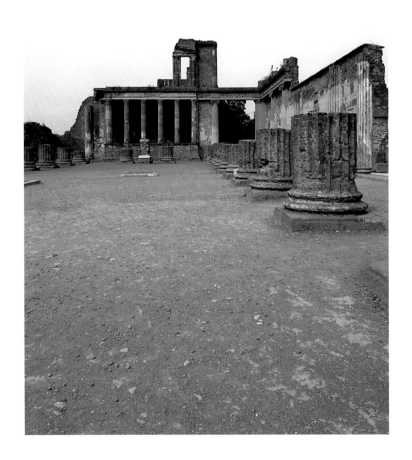

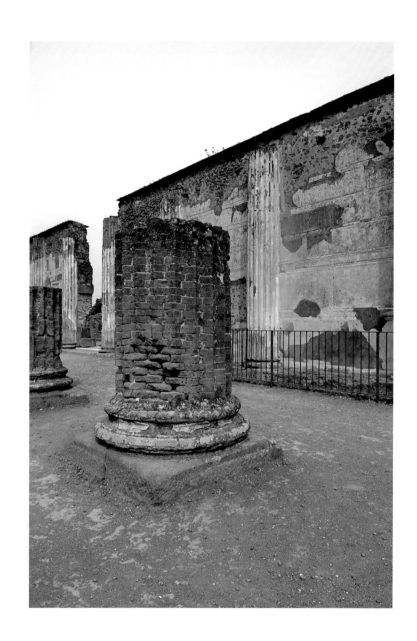

Before him a wide flight of stone steps leads to the Basilica, a space flanked by broken colonnades and enclosed by ruined walls. Here a woman stands, framed and diminished by the columns around her. She is shrouded in a cape and crinoline skirt, and her face is hidden in the shadow of a broad brimmed hat. In his letter to Cornelius Tacitus, Pliny the Younger said that the eruption of Vesuvius produced a cloud that resembled a pine tree. Before her a fallen section of Basilica wall frames the Gulf of Naples and the umbrella foliage of a Stone Pine. If she were to look beyond where he stands she would see the distant slopes of Vesuvius.

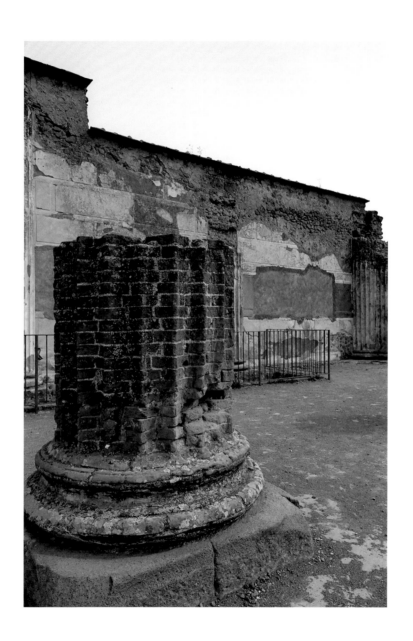

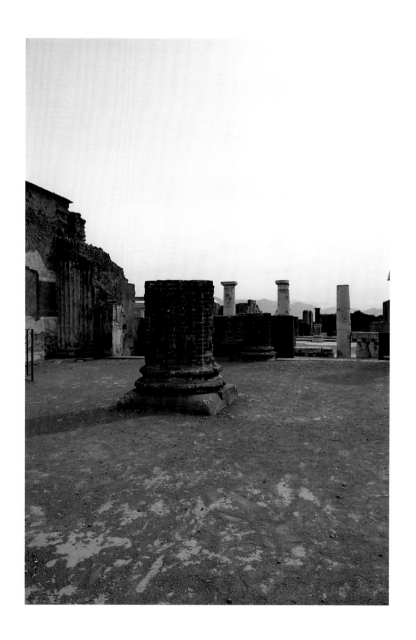

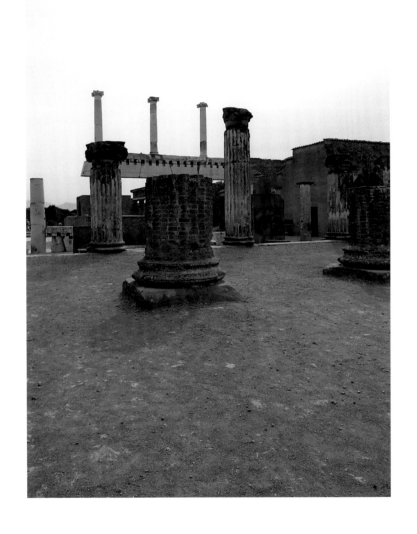

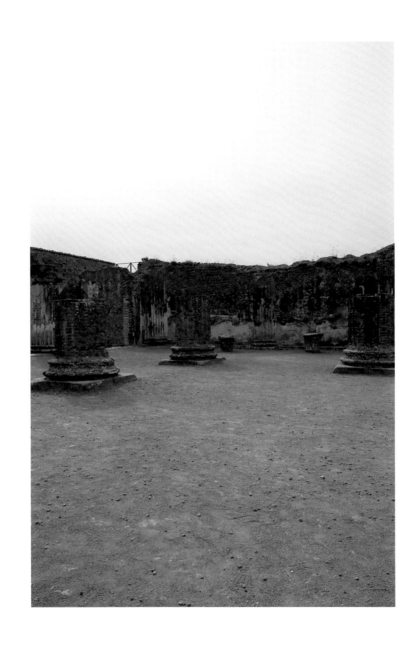

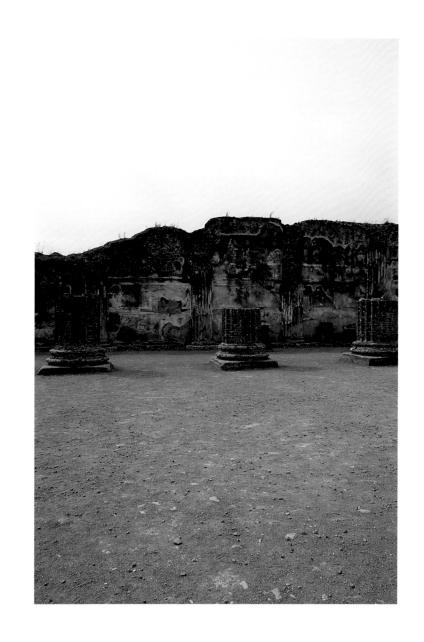

Carlo Fratacci
Active Naples ca. 1860s

*Basilica*
1864

Albumen silver print
17.4 x 18.1 cm (image, rounded corners)
28.2 x 30.4 x 2.7 cm (album)

Unnumbered plate from an album entitled *Principales Vues de Pompeii par Charles Fratacci, Naples 1864* comprising 26 photographs by Fratacci

Inscribed in ink on album page, below image: *Basilica*
Inscribed in ink on preliminary page: *A. Monsieur / Le Conte de Milano / Souvenir de / Carlo Fratacci / Naples 2 Mai 1864*

PH1983: 0504: 007
Collection Centre Canadien d'Architecture
Canadian Centre for Architecture, Montréal

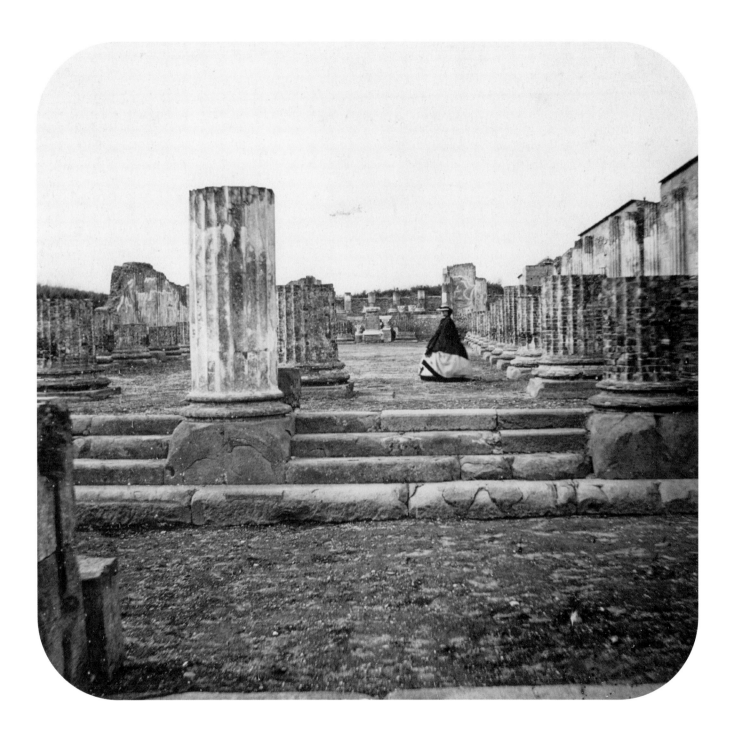

Basilica

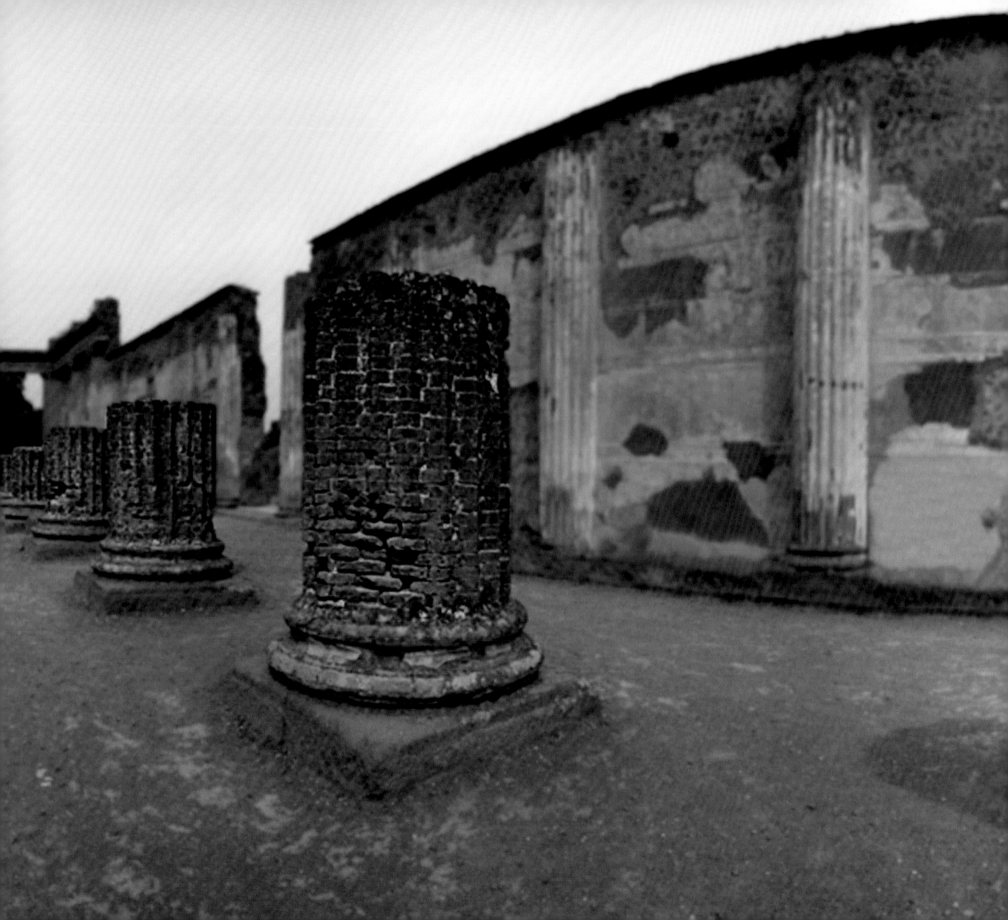

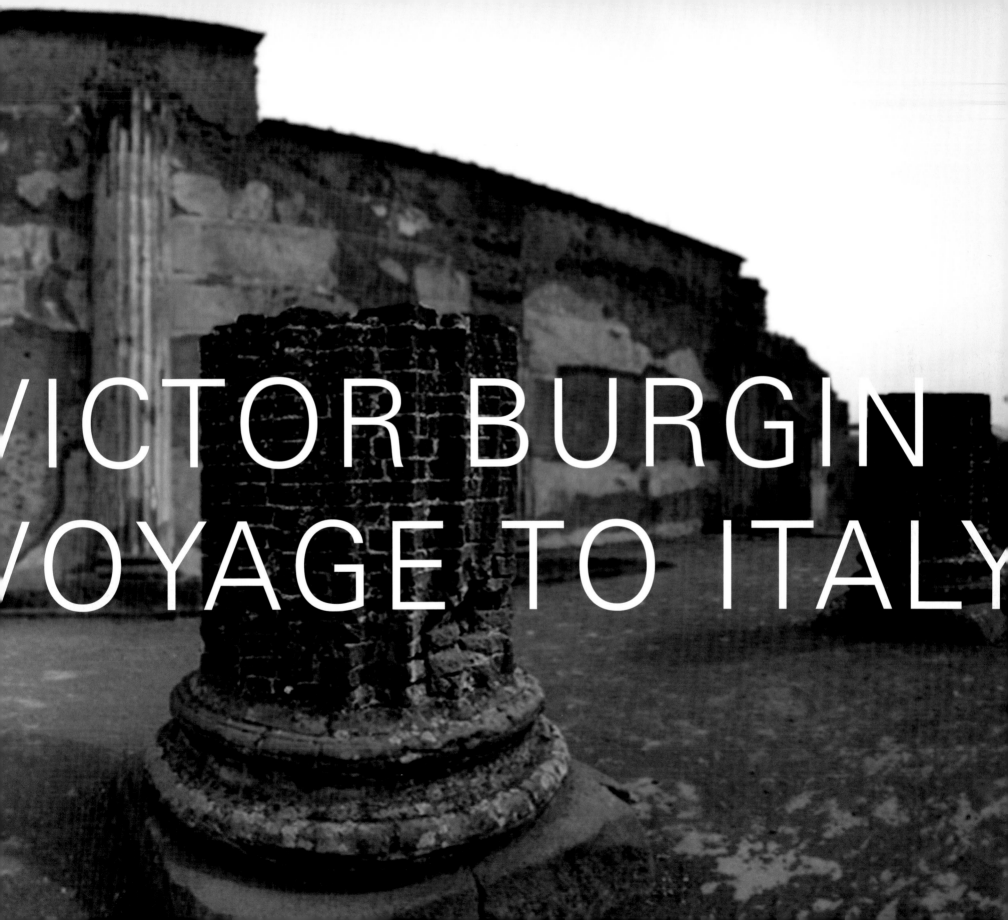

VICTOR BURGIN
VOYAGE TO ITALY

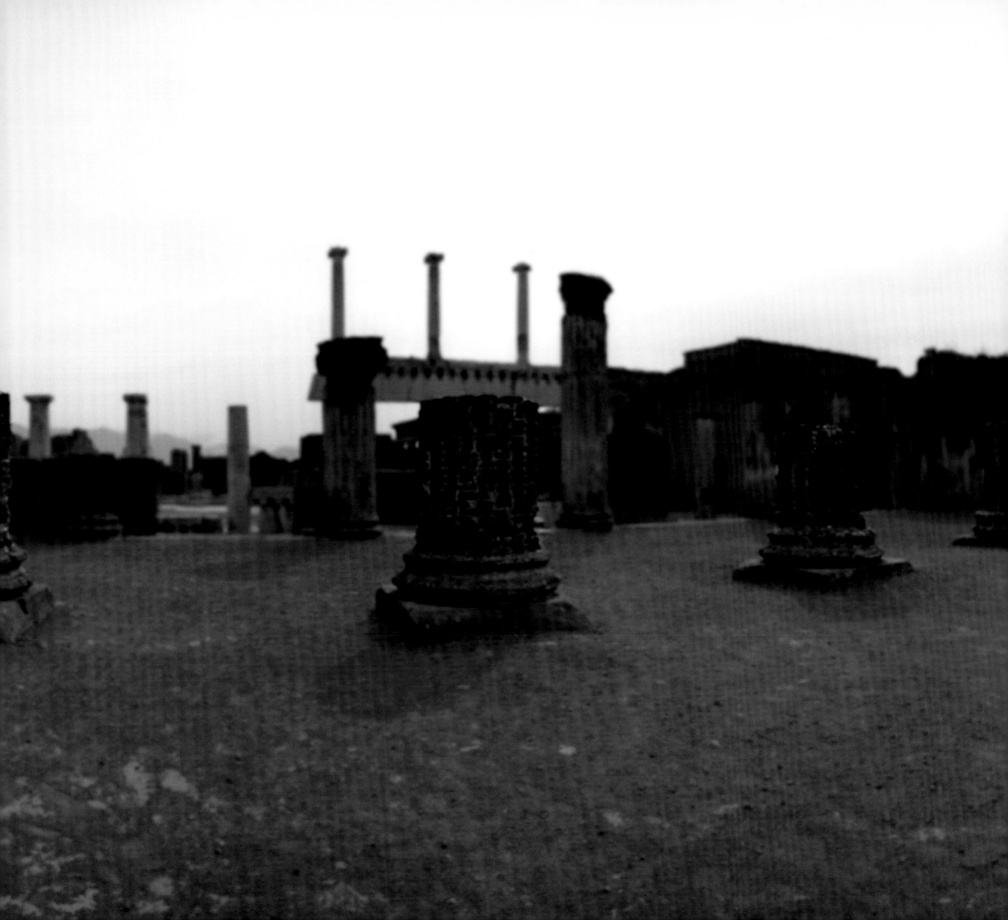

*Voyage to Italy* is the result of a commission by the Canadian Centre for Architecture (CCA) Montreal, given to Victor Burgin to create a work in response to a photograph in the CCA collection. The commission was issued in the context of the *Tangent* project curated for the CCA by Hubertus von Amelunxen.

# GALERIE THOMAS ZANDER/CANADIAN CENTRE FOR ARCHITECTURE

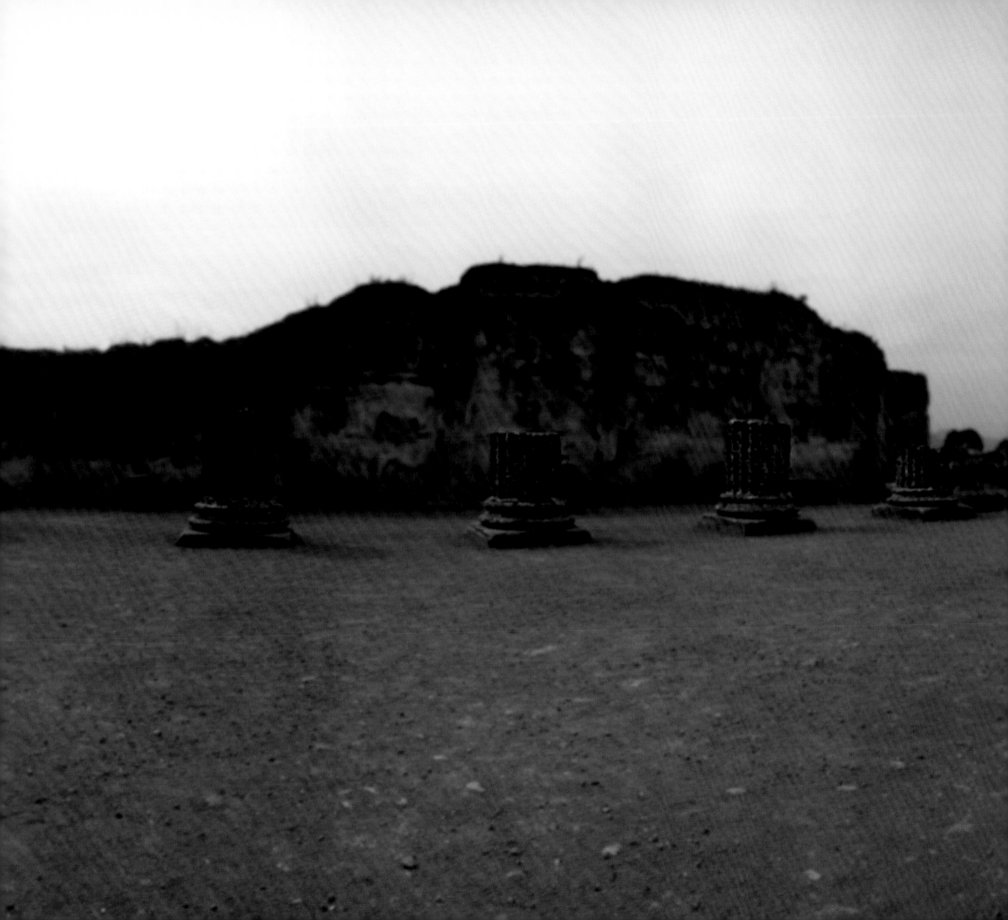

for Francette

# CONTENTS

# THE SHADOW AND THE RUIN

*For more than twenty years, each time I've returned to Naples, I've thought of her*

—Jacques Derrida, *Archive Fever* [1]

# VICTOR BURGIN

1 Jacques Derrida, *Archive Fever: A Freudian Impression,* trans. Eric Prenowitz
(Chicago and London, 1995), p. 97.

2 Carlo Fratacci, active Naples ca. 1860s, *Basilica,*
1864. Albumen silver print, 17.4 x 18.1 cm (image, rounded corners); 28.2 x 30.4 x 2.7 cm
(album). Unnumbered plate from an album entitled *Principales Vues de Pompeii par Charles Fratacci,
Naples 1864* comprising twenty-six photographs by Fratacci. Inscribed in ink on album page,
below image: *Basilica.* Inscribed in ink on preliminary page: *A. Monsieur | Le Conte de Milano |
Souvenir de | Carlo Fratacci | Naples 2 Mai 1864.* Collection Centre Canadien
d'Architecture/Canadian Centre for Architecture, Montréal: PH 1983:0504:007.

In the subterranean vault that houses the photographic archive of the Canadian Centre
for Architecture, in Montreal, is a nineteenth-century album of photographs of Pompeii.
In one of the images, a wide flight of stone steps in the foreground leads to a rectangular
space flanked by broken colonnades. A woman stands in this space, her voluminous
dress forming a broad-based cone, her face lost in shadow under the broad brim of a hat
with a dark ribbon. The photograph is captioned "Basilica." [2] No doubt the woman was
included in the photograph to lend a sense of scale to the architecture (she appears as if
miniaturized in relation to the stumps of columns around her) and this is why the caption
does not recognize her. Nevertheless, I am haunted by a different explanation: the woman
is a "midday ghost," she is not named because she is not seen. It is commonplace to note
the uncanny effect of photographs that show the apparently living presence of someone
long dead. Light reflected from a living being imprints itself in a photosensitive
emulsion; the impression persists unaltered by time. The entire architectural site of
Pompeii is an impression of this kind. Like a photographic plate, the surface of the city
has received the imprint of an event that has irreversibly transformed it. In a neologism,
Pompeii is a *catastrographic image* (one which, unlike Dresden and Hiroshima, remains so
in its entirety and in perpetuity), any photograph of Pompeii is therefore the impression
of an impression, the index of an index.

Pompeii is both an indexical sign and an architectural and archaeological archive. In his discussion of the relation between index and archive with which he concludes his book *Archive Fever*, Jacques Derrida invokes Wilhelm Jensen's novella *Gradiva*. Jensen's story tells of a young archaeologist fascinated by an antique relief of a woman stepping forward. He becomes obsessed by the question of whether the woman's gait depicted in the carving could have been drawn from life, or whether it was entirely the invention of the artist. He searches for Gradiva's ambulatory manner among women passers-by in the streets of the town where he lives, but without success. As obsession becomes delirium his search becomes a quest for Gradiva herself. He dreams that he sees her at the moment of her death, engulfed by the ancient eruption which destroyed Pompeii, and travels to the ruined city to seek some trace of her. Jensen writes: "with her peculiar gait she must have left behind an imprint of her toes in the ashes distinct from all the rest." In his commentary, Derrida speaks of "the impression and the imprint, . . . the pressure and its trace in the unique instant where they are not yet distinguished the one from the other."[3] This is the instant of a photographic exposure. More generally, it exemplifies the "subjectile" as construed by Derrida from the writings of Antonin Artaud.[4] Derrida gives the example of a work by Artaud in which, "with the aid a match, Artaud opens holes in the paper, and the traces of burning perforation are part of a work in which it is impossible to distinguish between the subject of the representation and the support of this subject, in the layers of the material, between that which is above and that which is below, and thus between the subject and its outside . . . ."[5]

Inadvertently anticipating a precept of architectural modernism, the ruin questions the distinction between interior and exterior, between public and private. The mid-eighteenth century excavations of Pompeii and Herculaneum prompted both a renewed fascination for the ruin, and the neoclassical revival. In the archive at the CCA, an institution with a historical association with Mies van der Rohe, I think of Mies' German Pavilion for the 1929 International Exhibition in Barcelona. Mies van der Rohe visited Pompeii in 1911, and it is not so very far from there to this pavilion where ruin and neoclassicism combine. Demolished in 1930, the German Pavilion was reconstructed in 1986 only after a long and arduous work of archival research and archaeology. The archive failed to render the precise profile and dimensions of the pavilion's cruciform columns, but these were determined when a rusting stump of pillar was unearthed during the excavation of the site of the original building. In Phillip K. Dick's novel *Martian Time-Slip* there is a ten-year-old boy whose apparently autistic withdrawal from the world has led to his confinement in a mental institution.[6] We learn that the space-time he inhabits is different from that occupied by those around him: where they see the present, he sees a palimpsest of present and future. What they are planning to construct, he sees as already in ruins. We are

3 Derrida 1995 (see note 1), p. 99.

4 Paul Thévenin and Jacques Derrida, *Antonin Artaud—Dessins et portraits* (Paris, 1986). The 1978 edition of the *Petit Robert* dictionary defines the *subjectile* as a "surface serving as support (wall, panel, canvas) for a painting." Derrida, however, notes that this is not how the term functions for Artuad, for whom the *subjectile* is that which lies "between the surfaces of the subject and the object" (Thévenin and Derrida 1986, p. 79). The *subjectile* is a "solidified interval" between "visible and invisible, before and behind, this side and that," the place where may be traced "the trajectories of the *objective*, the *subjective*, the *projectile*, of the *introjection*, the *interjection*, the *objection, of dejection*, and *abjection*, etc" (Ibid., p. 63).
5 Ibid., p. 70.

6 Philip K. Dick, *Martian Time-Slip* (New York, 1964).

7 Walter Benjamin, *Illuminations* (London, 1970), pp. 259–60.

8 George Kolbe, *Der Morgen,* 1925. The literal English translation of the title of this work is, of course, "The Morning." However, "Sunrise," and occasionally "Dawn," has become the most widely adopted English title. The original statue now stands in the gardens of the Schöneberg Town Hall, in Berlin.

told that the boy suffers from "the stopping of time. The end of experience, of anything new," such that "nothing ever happens to him again." The history of the last century, and the appalling beginning of the present century, has created a terrestrial space-time analogous to that of the ten-year-old boy on Mars, but with the difference that it is the past which we see superimposed on our present. This is the cataclysmic vision of the "angel of history," pictured by Walter Benjamin as impelled backwards into the future by a storm "blowing from Paradise" while its retrospective gaze is fixed upon the skyward growing pile of wreckage of "one single catastrophe" accumulating at its feet. Benjamin writes: "This storm is what we call progress."[7] The opening sequence of Roberto Rossellini's film of 1947 *Germany Year Zero* is a travelling shot from a vehicle moving down Berlin streets between ruined walls and mounds of rubble. The camera offers the spectator a feeling of gliding through the debris without touching the ground, the kind of motion conventionally ascribed to ghosts. One might suppose that this is how the ghosts that haunt Pompeii must view their own ruined streets. The ruined streets of another first-century Roman city makes up the basement level of Barcelona's Museu d'Historia de la Ciutat (Museum of the History of the City). A walkway suspended just above the excavation floor allows the visitor to walk among vestiges of buildings, stumps of columns and skeletal walls. Its almost invisibly light construction gives a sense of floating to the sunken *flâneur* who drifts among the stones like a ghost from the future: a living body among deceased buildings, enacting a haunting in negative. In Rome, with its profusion of statues, Goethe saw a world where marble ghosts mingle with the living; the mutual reflections and refractions of visitors to the Barcelona German Pavilion mingle in the angled glass walls with the form of a bronze statue, titled *Sunrise* it shows a woman standing with arms raised to shade her face from the light.[8] The title disavows the violence in this image, the woman's face is averted as if from an undisclosed horror coming from the skies—as if she already served, in 1929, as a memorial to a cataclysm yet to come: the first aerial bombardment of a civilian population, at Guernica, in 1937.

The first atomic bombardment of a civilian population was at Hiroshima, in 1945. The opening sequence of Alain Resnais' film of 1959 *Hiroshima mon amour* is a close-up of the upper bodies of a couple in an embrace. What appears to be a rain of ash is falling on them in darkness, giving a granular whiteness to their arms and torsos, as if they are turning to stone. The frozen gesture of the statue of the woman in the Barcelona Pavilion recalls those revealed by casts of bodies made from the ashes of Pompeii. Towards the end of Rossellini's film of 1953 *Journey to Italy* the unhappily married protagonists drive to Pompeii, where they watch as a plaster cast is made from a natural mold in the compacted volcanic ash, a mold formed from a cavity left after the disintegration of bodies buried in the eruption. When the cast is finally freed from the ground it reveals

the figures of a man and a woman, side by side at the moment of their death. Raymond Bellour observes: ". . . there emerges the form of a couple . . . as a picture appears in a developer. Thus a photograph is formed from the real itself."[9] In his novella of 1809 *Elective Affinities* Goethe describes a party in a country house at which guests amuse themselves by staging a *tableau vivant*. They unanimously agree that "this living reproduction by far exceeded the original," nevertheless, the narrator remarks: "the presence of the real instead of the illusory produced a sort of unease."[10] In Naples, in 1787, Goethe had witnessed a precursor to the tableau vivant in the solo mime performances, "attitudes," of Miss Emma Hart, the future Lady Hamilton. In a journal entry, Goethe writes:

> Sir William Hamilton . . . has now, after many years of devotion to the arts and the study of nature, found the acme of these delights in the person of an English girl of twenty with a beautiful face and a perfect figure. He has had a Greek costume made for her which becomes her extremely. Dressed in this, she lets down her hair and, with a few shawls, gives so much variety to her poses, gestures, expressions, etc., that the spectator can hardly believe his eyes. . . . standing, kneeling, sitting, reclining, serious, sad, playful, ecstatic, contrite, alluring, threatening, anxious, one pose follows another without a break . . . in her, he has found all the antiquities . . . .[11]

Emma Hart's audience might have felt they were watching a classical frieze incrementally revealed. Reading Goethe's description today we may more readily think of a film on DVD periodically paused on playback. Laura Mulvey observes that classic Hollywood melodramas tend to favor "frozen moments," and notes Douglas Sirk's use of "slightly marionette-like performances to privilege gestures and looks, suspended in time."[12] The circumstances of Miss Hart's performances did not lack a melodramatic dimension. One evening, Sir William opened his "secret treasure vault" to Goethe and the landscape painter Philipp Hackert. Among a profusion and confusion of works of art and junk Goethe came across two magnificent candelabra: "I nudged Hackert and asked him in a whisper if they were not very like the candelabra in the Portici Museum. He silenced me with a look. No doubt they somehow strayed here from the cellars of Pompeii."[13] Goethe continues:

> I was greatly intrigued by a chest which was standing upright. Its front had been taken off, the interior painted black and the whole set inside a splendid gilt frame. It was large enough to hold a standing human figure, and that, we were told, was exactly what it was meant for. Not content with seeing his image of beauty as a moving statue, this friend of art and girlhood wished also to enjoy her as an inimitable painting, and so, standing against this black background in dresses of various colors, she had . . . imitated the antique paintings of Pompeii . . . [14]

9 Raymond Bellour, "The Film Stilled," *camera obscura*, no. 24 (September 1990), pp. 109–10.

10 Johann Wolfgang von Goethe, *Elective Affinities* (Oxford and New York, 1994), p. 147.

11 Johann Wolfgang von Goethe, *Italian Journey* (Harmondsworth, 1970), p. 208.

12 Laura Mulvey, *Death 24x a Second: Stillness and the Moving Image* (London, 2006), p. 146. Emma Hart's attitudes may today also bring to mind those of "Augustine," Charcot's most celebrated hysteric at the Salpêtrière hospital, whose postures were frozen in sequences of photographs. See Georges Didi-Hubermann, *Invention de l'Hysterie: Charcot et l'Iconographie Photographique de la Salpêtrière* (Paris, 1982), pp. 113ff.

13 Goethe 1970 (see note 11), p. 315.

14 Ibid., pp. 315–16.

15 François-René de Chateaubriand, *Voyage en Italie, Oeuvres romanesques et Voyages,* vol. II (Paris, 1986), p. 1474.

16 *Théophile Gautier, Arria Marcella: Souvenir de Pompéi* (Paris, 2004), p. 16. In his *Corricolo. Impressions de voyage en Italie,* of 1842, Alexandre Dumas gives a long and detailed account of his visit to the so called "Villa of Arrius Diomedes" (opportunistically named after a nearby tomb to this gentleman), which includes a descent into the subterranean gallery where the inhabitants of the house had sought refuge and been suffocated. He reports that the ashes that had covered them had been followed by an inundation of water, and that the mud produced had dried slowly and "enveloped their corpses like a mold." When they were found, he continues: "their corpses were perfectly conserved; but at the merest touch of a finger these fell into powder, leaving nothing but their bones. The mud that contained them remained more solid and there is conserved in the museum in Naples a fragment of this earth in which is imprinted a magnificent breast of a woman, on the surface of which one can make out the folds of a muslin dress. A second fragment keeps the mold of two shoulders; a third, the contours of an arm: all rounded and young, all magnificent in form." Some pages later Dumas returns to contemplate *le morceau de cendre coagulée,* which conserves the imprint of the breast, in almost exactly the same words that Gautier will use in his *Arria Marcella,* published ten years later: un morceau de cendre noire coagulée. The mud disintegrated while on display in Naples, and it seems unlikely that Gautier himself saw it. See, *Alexandre Dumas, Corricolo. Impressions de voyage en Italie* (1842), extract in Claude Aziza, ed., *Pompei: Le rêve sous les ruines* (Paris, 1992), pp. 446, 479.

17 Ibid.

18 Ibid., pp.71–2.

19 Ibid., p. 75.

20 Roland Barthes, *La Chambre Claire* (Paris, 1980), pp. 55–6; translated as *Camera Lucida* (New York, 1981).

21 Goethe 1970 (see note 11), p. 211.

The intimations of premature burial and necrophilia here might have come from a tale by Edgar Allen Poe. Beginning with eyewitness accounts of the destruction of Pompeii in AD79, followed by the first travellers' tales of a buried city in 1594, and then in the works of travel literature and fiction that followed upon the first systematic excavations of the city in 1748, Pompeii has been *narrated*. It is unlikely that Emma's protector would have been ignorant of the second volume of Chateaubriand's *Voyage en Italie, Oeuvres romanesques et Voyages,* published in 1783. The following account begins near the Porta di Ercolano, where the Via Consolare gives way to the Via delle Tombe:

> The street leads to a gate where a portion of the city walls have been exposed. At this gate began the line of tombs that bordered the public way. Having passed the gate, one comes upon the country house that is so well known. The portico that surrounds the garden of this house is composed of square pillars, grouped in threes. Beneath this first portico, a second exists: here was suffocated the young woman whose breast is imprinted in the piece of earth that I saw at Portici: death, like a sculptor, has molded his victim.[15]

The young hero of Théophile Gautier's novella *Arria Marcella* is seized by "a retrospective love" as he contemplates this "piece of coagulated black ash" in its display case in the Portici museum, and sheds a tear that arrives "late by two thousand years" as with an "artist's eye" he recognizes in the imprint "the form of an admirable breast and of a thigh as pure in style as that of a Greek statue."[16] The soul of the eponymous and unfortunate Arria responds across time to the young man's yearning; alone at midnight in the ruins of Pompeii he is granted a vision of sunlit streets restored to their original state, down which he wends his way into the arms of the revivified girl, her eyes "charged with an indefinable expression of voluptuous sadness and passionate ennui."[17] Rising and falling against his heart the young man feels "this beautiful breast, of which only that morning he had admired the mold through the glass of a museum display cabinet."[18] But on the sounding of the Angelus bell in a distant village he finds beside him nothing more than "a pinch of ashes mixed with a few calcified bones among which shone some bracelets and gold jewellery."[19]

Roland Barthes remarks: "Photography is like a primitive theatre, like a Tableau Vivant, a figuration of the immobile and made-up face beneath which we see the dead."[20] Most of Pompeii and Herculaneum was still buried at the time of Goethe's visit, he writes: "We descended a flight of sixty steps to a vault, where we admired by torchlight the former open-air theatre, . . ."[21] We may admire the theatres of Pompeii, open to sepia-tinted Campanian skies, in the album of photographs in the subterranean vault of

the Canadian Centre for Architecture, but the photograph of the woman in the Basilica is the most *theatrical* image in the album. She stands in a rectangular space lined with broken columns and enclosed on three sides by ruined walls. A structure of indeterminate function, but suggesting a dais or altar closes the perspective behind her.[22] From the open side of the space, stone steps lead to the inferior level from which the camera sees her. In effect, the woman is on stage. We might be in that still and expectant operatic moment between the end of the orchestral introduction and the first note of the aria. "Una macchia . . . ," perhaps, the aria from Verdi's *Macbeth* that Maria Callas sang for the first time in public at La Scala, Milan, in 1952 as postwar Europe was emerging from its ruins. The poor technical quality of the live recording of this event wreaths Callas and her enraptured audience in an electric ectoplasm, creating an impression of voices "from the other side." *Una macchia*—a spot, a stain, a mark, a blot. This is what the woman in the Basilica forms in the field of vision opened by the camera—the look given by the camera which should, by the laws of perspective, be allocated to me, but of which I am deprived by her inassimilable presence. The lines of perspective converge on the place from which the woman gives her own invisible look, producing what Derrida has called the ghost's "visor effect": the woman can "see without being seen or without being identified."[23] It is precisely according to the terms in which Derrida defines the specter that I first intuitively identified this woman as a mid-day ghost: "The specter is not simply someone we see come to return *(venir revenir)*, it is someone by whom we feel ourselves watched, observed, supervised *(surveillés)*, as if by the law: we are "before the law," without possible symmetry, without reciprocity . . . ."[24]

In Ken McMullen's film of 1983 *Ghost Dance,* Pascale Ogier asks Jacques Derrida if he believes in ghosts; having answered her at some length he asks in return: "And you, do you believe in ghosts?"; to which the actress replies (across a sequence of dissolves between alternate takes): "But certainly"; "Yes, absolutely"; "Now, absolutely"; "Now certainly"; "Now, of course." In the United States two or three years after the film appeared, Derrida found himself watching the film again at the request of, and in the company of, students in his seminar class. In the interim Pascale Ogier had died: "I suddenly saw appear on the screen the face of Pascale, which I knew to be the face of a dead person. She answered my question: "Do you believe in ghosts?" Looking me almost in the eyes, she said to me again . . . : "Yes, now, yes." Which "now?"[25] The spectral "now" is out of time, the spectral moment is: " . . . a moment that no longer belongs to time, if one understands by this name the chaining *(enchaînement)* of modalized presents (past present, actual present, "now," future present). . . . Furtive and untimely *(intempestive)*, the appearance of the specter does not belong to that time . . . ."[26] Out of my time, the look given by the specter is also out of my place, it is the point of "a singularity from which a

22 This structure is in fact the tribunal, from which justice was dispensed.

23 Jacques Derrida, *Spectres de Marx* (Paris, 1993), p. 28; translated as *Specters of Marx* (London, 1994).

24 Jacques Derrida and Bernard Steilger, *Échographies, de la télévision* (Paris, 1996), p. 135; translated as *Echographies of Television* (London, 2002).

25 Ibid., p. 120.

26 Derrida 1993 (see note 23), p. 8.

world opens." Derrida writes: "Pascale Ogier had seen, she will have seen, she saw. There was a world for her. From this other origin, that which I cannot re-appropriate, from this infinitely other place I am looked at, today still that looks at me *(cela me regarde)* and asks me to respond or to be responsible."[27]

I began by remarking that it is commonplace to note the uncanny effect of photographs that show the "living" presence of someone long dead, a consequence of the indexical nature of the photograph. In his book of 1980 *Camera Lucida*, Roland Barthes observes:

> The photograph is literally an emanation of the referent. From a real body, which was there, depart radiations which come to touch me, I who am here . . . A sort of umbilical cord connects the body of the thing photographed to my gaze: light, though impalpable, is here a carnal medium, a skin that I share with he or she who has been photographed.[28]

Barthes speaks of the photograph as "an emanation of past reality: a magic." His language here may evoke that of Jean-Paul Sartre, to whose book of 1940, *l'Imaginaire*, Barthes dedicates *Camera Lucida*. Sartre writes that the act of imagination is "a magical one . . . destined to produce the object of one's thought, the thing one desires, in such a way that one can take possession of it. In that act there is always something of the imperious and the infantile."[29] Barthes' mother had recently died at the time he wrote *Camera Lucida*, the photographs he comments upon serve ultimately to support the "act of imagination" that is mourning as described in Freud's essay of 1917 "Mourning and Melancholia": an imaginary presence takes the place of the real absence of the object, in order that the attachment to the real object may be gradually relinquished, and the ideal object be assimilated into the ego. Barthes describes his project in *Camera Lucida* as a search for the "essence" of photography, the term is to be understood in the sense it takes in phenomenological philosophy: *eidos*—the factor, or factors, common to all phenomenological experience of photographs. In principle (for all it is difficult to maintain the distinction in practice) this project is prior to, and distinct from, the act of interpretation—whether theoretical or anecdotal. We may agree with Barthes that what essentially distinguishes the photograph from other forms of analogical visual representation is its indexical relation to a *real* referent (albeit digital photography may put this in question); but this does not commit us to seeing the relation to the referent as invariably either "magical" or "umbilical." I share no intimacy with the woman in the Basilica; unidentified, unknowable, she is indifferent to me. Her body as erect as the columns around her, the fall of her garments echoing the form of the distant Vesuvius, her relation to her surroundings is almost mimetically self-effacing.[30] Haunted, I neither

27 Derrida and Steigler 2002 (see note 24), p. 123.

28 Barthes 1981 (see note 20), pp. 80–81.

29 Jean-Paul Sartre, *The Psychology of Imagination* (London, 1972), p. 141.

30 Albeit incongruously, I am reminded of the insects described by Roger Caillois. See Roger Caillois, *Méduse et Cie* (Paris, 1960).

comprehend nor contain her; haunting, she is *encrypted*. In a passage in James Joyce's *Ulysses*, Stephen Dedalus contemplates the sea, each aspect of which evokes for him the recent death of his mother. Commenting on this passage, Georges Didi-Hubermann remarks on the historical association of all seeing with loss. He notes that mediaeval theology found it necessary to distinguish between the concepts of *imago* (image) and *vestigium* (vestige, trace, ruin) in order to explain how the visible world carries the trace of a lost resemblance, how the visible world is the ruins of a resemblance to God which was lost through sin. In the different context of modernist aesthetics, Didi-Hubermann cites the desire expressed by the painter Jasper Johns to produce: "an object that tells of the loss, destruction, disappearance of objects."[31] But such an object already exists—it is the photograph. Every photograph is the trace of a previous state of the world, a vestige of how things were. The sum of all photographs is the ruin of the world.

In the photogram, the most elemental form of photography, an object is placed between a source of light, or other form of radiation, and a sensitive surface. The image that results is the shadow of the object. The Hiroshima branch of the Sumitomo Bank is about 800 feet from the hypocenter of the atomic blast that destroyed the city on the morning of August 6, 1945. At this distance the explosion created temperatures at ground level of over 5,000 degrees Fahrenheit for a duration of about three seconds. This exposure incinerated someone who was sitting on the flight of stone steps at the main entrance to the building, perhaps waiting for the bank to open. The shadow of this individual, believed to be that of a woman, was inscribed in stone, and remained clearly visible for about ten years before it began to fade.[32] It is likely that the woman in Fratacci's fading photograph would have been dead before World War I reduced her world to rubble, and yet her shadow might be haunting the aftermath of the conflict, it might be her image that inspired Walter Benjamin's observation:

> A generation that had gone to school in horse-drawn streetcars now stood in the
> open air, amid a landscape in which nothing was the same except the clouds and, at
> its centre, in a force field of destructive torrents and explosions, the tiny, fragile
> human body.[33]

Already, in 1852, the hero of Arria Marcella had cause to allude to the modern world closing upon Pompeii. The black volcanic dust of Campania prompts thoughts of industrialization; he finds that the villages through which he passes between Naples and Pompeii have "something Plutonian and ferric about them, like Manchester and Birmingham." On arrival, by rail, he and his friends are amused by the incongruity of the sign "Pompeii Station."[34] (In 1875 Mark Twain found the whistle call of the railway train at Pompeii "as unpoetic and disagreeable as it was strange.")[35] Political modernity was keeping pace with

31 Georges Didi-Hubermann, *Ce Que Nous Voyons, Ce Qui Nous Regarde* (Paris, 1992), pp. 14–15.

32 When the bank was rebuilt, in 1971, the section of stones bearing the shadow was removed to the Hiroshima Peace Memorial Museum.

33 Walter Benjamin, "Experience and Poverty," in *Walter Benjamin: Selected Writings, Volume 2 1927–1934* (Cambridge MA and London, 1999), p. 732.

34 Gautier 2004 (see note 16), pp. 18–21.

35 Robert Etienne, *Pompeii: The Day a City Died* (London, 1997), p. 169.

36 Ibid., pp. 198–205.

37 Madame de Staël, *Corinne ou l'Italie* (1807), IX, 4. Extract in Aziza 1992 (see note 16), p. 35. The description suggests that Madame de Staël visited the subterranean gallery at the Villa of Diomedes.

38 Sigmund Freud, "Delusions and Dreams in Jensen's *Gradiva*" (1907), *The Standard Edition of the Complete Psychological Works of Sigmund Freud,* vol. 9 (London, 1955–74), p. 21.

industrial modernization. The Neapolitan Carlo Fratacci made his photograph of the woman in the Basilica in 1864, during that crucial phase of the *Risorgimento* following the march of Giuseppe Garibaldi and his Red Shirt volunteers upon the Bourbon King of Naples. Nor is the site of Pompeii itself frozen in history. The Basilica was badly damaged in a major earthquake that struck Pompeii in AD62, and was being rebuilt at the time the city was buried by the eruption of Vesuvius in AD79. The apparently "broken" columns that surround the woman in the Basilica are merely incomplete, a fact confirmed by their exposed brickwork (to reduce building costs many columns were built of brick, and then finished with stucco painted to simulate marble). Since the time that Fratacci's photograph was taken, the six Corinthian columns that grace the raised platform of the tribunal behind the woman in the Basilica have been reconstituted, together with part of a smaller colonnade and decorative pediment above them. Together with such reconstruction there is continuing degradation from tourism, vandalism, theft and official neglect.[36] The Basilica as it appears today is a moving palimpsest.

The woman in the Basilica is a mid-day ghost, I see through her to other women who haunt her. Writing from "the rim of Vesuvius, right near Pompeii" Derrida confesses that for more than twenty years, each time he returned to Naples, he has "thought of her." Of whom? His following paragraph refers the reader to Gradiva, but his paragraph break leaves the ghost of a question in the air. The ashes of Pompeii bear the real and fictional impressions of many women: they include the unknown girl whose body left its trace in the cellar of the Villa of Diomedes, and her reincarnation in Arria Marcella, in whose steps Gradiva followed; Emma Hart's step must surely have disturbed the Pompeian ash, as did that of Madame de Staël, whose surrogate heroine "Corinne" preceded the hero of Arria Marcella in witnessing: "the remains of a woman… still decked out in the finery she wore on the public holiday the volcano had interrupted, … her desiccated arms no longer filling the jeweled bracelets that still encircled them."[37] Beset with melancholy musings on "this history of the world where epochs are counted from ruin to ruin," Corinne concludes that either the very air one breaths in Pompeii must be "imprinted" with such thoughts or they are forever deposited (*déposées*—we might say archived) in the Pompeian skies. Like Pompeii, the ruin that is photography has the potential to prompt such thoughts—a potential latent to the essence (*eidos*) of photography. Melancholy, however, like the beauty it also shadows, is in the eye of the beholder. Having pursued his midday ghost through the ruins of Pompeii, Norbert Hanold finally confronts his elusive shadow. His "Gradiva" tells him that her real name is "Zoe":

> "The name suits you beautifully, but it sounds to me like a bitter mockery, for Zoe means life." "One must bow to the inevitable," was her reply, "and I have long been used to being dead."[38]

*Gradiva* (1982)

7 black and white photographs

Each image 30 x 45 cm. Each frame 52 x 62 cm

Overall dimensions 52 x 476 cm

GRADIVA

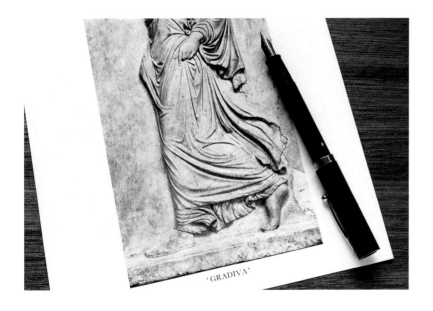

'GRADIVA'

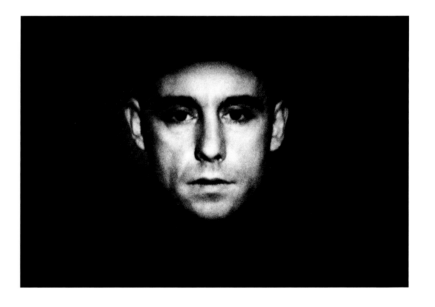

SHE WAS RAISED
BY HER FATHER,
A DISTANT MAN,
FOREVER LOST
IN HIS WORK.

IN CHILDHOOD SHE FOUND COMPANIONSHIP
WITH A NEIGHBOUR'S BOY OF HER OWN AGE.
YEARS LATER, NOW ADULT, SHE ENCOUNTERED HIM AGAIN, BY CHANCE;
HE SHOWED NO SIGN OF HAVING RECOGNISED HER,
WHICH PLUNGED HER INTO DESPAIR.

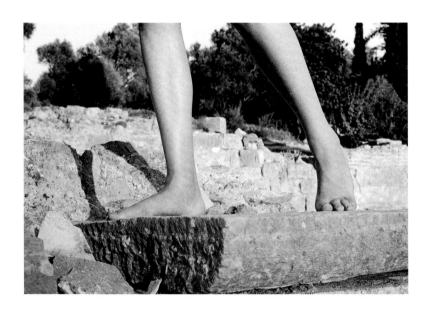

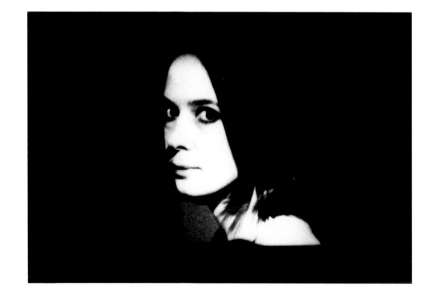

SHE COULD TAKE NO INTEREST IN ANY SUITOR.
SHE RESIGNED HERSELF
TO THE COMPANIONSHIP OF HER FATHER,
ACCOMPANYING HIM
ON HIS TRIPS ABROAD.

IT WAS WHILE SHE WAS VISITING
THE RUINS OF POMPEII
THAT SHE BECAME AWARE OF
THE FIGURE OF A MAN
WATCHING HER.

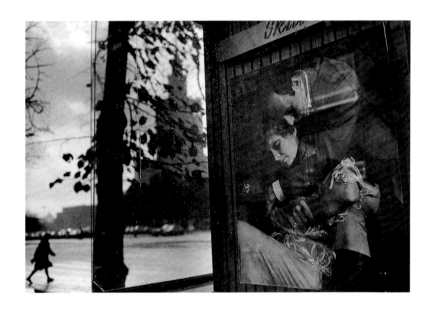

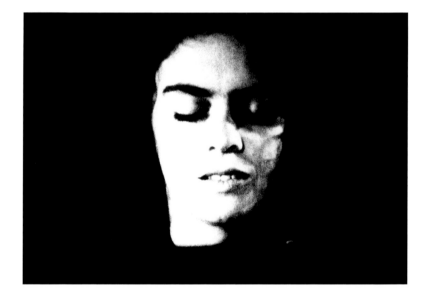

ALONE
IN THE RUINED STREETS
HE WAS STARTLED BY THE SUDDEN APPEARANCE OF
THE FIGURE OF A WOMAN
MOVING WITH GRADIVA'S UNMISTAKEABLE GAIT.

IN A DREAM OF THE DESTRUCTION OF POMPEII
HE BELIEVED HE SAW GRADIVA, AS IF TURNING TO MARBLE.
HE RESOLVED TO TRAVEL TO POMPEII
IN THE HOPE OF FINDING SOME TRACE OF
THE LONG-BURIED GIRL.

My gaze slid by chance towards the massive mirror hanging in front of us and I uttered a cry: in this golden frame our image appeared like a painting, and this painting was marvellously beautiful. It was so strange and so fantastic that a deep shiver seized me at the thought that its lines and its colours would soon dissolve like a cloud.

THE RELIEF REPRESENTED A YOUNG WOMAN, STEPPING FORWARD.
ONE FOOT RESTED SQUARELY ON THE GROUND,
THE OTHER TOUCHED THE GROUND ONLY WITH THE TIPS OF THE TOES.
THIS POSTURE CAME TO HAUNT HIS THOUGHTS;
HE GAVE THE GIRL THE NAME 'GRADIVA' – 'SHE WHO STEPS ALONG'.

Norbert Hanold travels to the ruins of Pompeii, where he encounters what, in his unhinged state of mind, he takes to be Gradiva's ghost. This "ghost" turns out to be the young adult form of Norbert's long-lost childhood playmate, Zoe. Zoe, who has never stopped loving Norbert, recognizes him right away. The rest of the tale is a story of how she gently coaxes him back to reality—for *he* is the one who has become "not of this world." Having regained his senses Norbert again falls madly in love with Zoe—who, of course, he had really loved all along in the form of his Gradiva delusion—and they live happily ever after.

The lives of these two young lovers, following their separation in childhood, form trajectories towards their encounter in the street in Pompeii. I was made to think of that much overdone scene from popular film and television romances where the lovers run towards each other from opposite sides of the frame—through a field, along a city street, or a beach—finally to throw themselves, as the orchestra whips itself into a frenzy, into each other's arms. I wanted to represent a situation in which the lovers run towards each other, and *miss*—like two express trains hurtling by on their separate tracks, towards their individual destinations. I was thinking of the celebrated and notorious remark made by Lacan in one of his seminars, he said: *"Il n'y a pas de rapport sexuelle"*—"there is no sexual relation." In an Egyptian myth, Isis and Osiris were once one, but a catastrophe split this "one" into two beings—male and female—who were thereafter condemned to wander the earth in eternal search of reunion. There are other such myths. The lovers who crash together in modern soap operas as are the descendants of this ancient quest for (re)unification: Mr and Ms Right come together in perfect mutual complementarity. But what of the message in the myths—that (re)union is never achieved? I interpret Lacan's remark—"there is no sexual relation"—to mean that the supposed relation of complementarity is a misrecognition of the fact that the only relation here is in fact with a fantasy. We project an image upon the other, and become in turn the screen upon which

the other projects their fantasy upon us. It is in the gap between fantasy and reality that many such "relationships" eventually founder. Jensen's story ends on a conventionally complacent note. I wanted to counter this by throwing Norbert's obsession with the relief *into* relief. Norbert's sexual relation is with an *image,* which prevents his establishing a relationship with the real Zoe. In the novel, Norbert's behaviour is seen as thoroughly abnormal, and he is subsequently shown as "cured." I wanted to imply that Norbert's behaviour is in fact and novelistic staging of what is perfectly *normal* masculine sexuality, and that there was therefore no real reason to suppose that Norbert was capable of spontaneously giving up this form of relation with his "object."

For this work I "rewrote" Jensen's novel in the "lapidary" form—a writing adapted to the needs of inscriptions on monuments, and to the stone-carver's art. Photographs of course are all, in a way, monuments to the past. I further rewrote the book in giving as much weight to Zoe's story as to Norbert's—the book is primarily about Norbert. I put Zoe's story first in terms of a conventional left-to-right reading. Norbert's story reads from right-to-left—from the final image towards the center of the work as a whole. The central image is where the woman in the image turns to meet our gaze, where Zoe in the text turns to meet Norbert's gaze, and where the story pivots into Norbert's perspective. Up to this point you are given Zoe's point of view—you are drawn into her position in the written text, and you are given her position by the camera when you, as *viewer,* look at the face of the man who may represent Norbert. Once you begin, from the central image on, to see women in these dark close-ups, then you have stepped into Norbert's shoes. I have said that the piece is composed to allow readings which proceed towards each other from left and right extremities—like the lovers moving towards each other along the paths of their lives, or from left and right of the cinematic frame. Of course they can also be read conventionally, from left to right, and in this reading you are brought full circle back to the desk at which you began—along with Freud (who had daughters of his own) "lost in his work." (Incidentally, my own reading of *Gradiva*—concentrating as it does on fetishism and scopophilia—has little in common with Freud"s reading of the book.) Showing slides of the work, or even seeing it reproduced on successive pages of a magazine, you lose some of the complexity of the readings which are encouraged where you see it "in one piece," on the gallery wall. This form of visual art practice, to some extent, is analogous to pictographic, hieroglyphic, writing—which is not linear in the sense in which modern alphabetic writing is linear. Early alphabetic writing, for a while, retained some of this—early Greek and Latin characters had no fixed direction of reading and writing. If you take a conventional reading of this piece, then it is as if the narrative, as it progresses beyond the midpoint, "meets itself coming back" in the opposite direction.

# AFTERWORD

# HUBERTUS VON AMELUNXEN

1 Walter Benjamin, "Rundfunkgeschichten für Kinder", in idem, *Gesammelte Werke,* Vol. II, eds. Rolf Tiedemann and Hermann Schweppenhäuser (Frankfurt am Main, 1989), p. 220.

Between 1929 and 1932 Walter Benjamin gave a series of radio lectures for children in which he addressed not only his chosen theme but also the fact that the time horizon of the lectures was determined by the medium of radio itself. Benjamin explained that just as a pharmacist puts gram after gram on the scales when making up a prescription, so in the case of his lecture minutes would be weighed so that they would be precisely distributed to achieve the right narrative in the given time of the broadcast. His last lectures, in 1931 and 1932, were devoted to past catastrophes: the Lisbon earthquake, the Firth of Tay railway bridge disaster, and the destruction of Herculaneum and Pompeii. On September 18, 1931, on Berlin Radio, Walter Benjamin could be heard saying this about the eruption of Vesuvius in AD79: "To the same extent as it was, for the people then, the annihilation of a blossoming city, for people today it was its preservation."[1] To see an event of preservation in an event of destruction is an uncanny inversion. Benjamin's attention was drawn to the impressions and imprints left behind by people in the rain of ash, as their decay left hollows which would form the basis for a future memorial by allowing plaster casts to reconstruct, two millennia later, the agonal departure of a whole city. That burying alive of life brought to light "completely sharp and true-to-life images of people who lived more than 2000 years ago." Since the first excavations in the eighteenth century (Goethe described his visit to Pompeii on March

II, 1787 as a "strange, partly unpleasant impression of this mummified city") and then in the course of the nineteenth century, after the invention of photography, this "uncanny" proximity to life of what had been removed provided material for many Pompeian idylls, the best known of which are surely Théophile Gauther's *Arria Marcella, souvenir de Pompei* (1852) and the novel by Wilhelm Jensen *Gradiva: Ein pompejianisches Phantasiestück* (1903), which gained fame mainly because of Freud's interpretation of it. Artists and photographers have also visited Pompeii; the latter have filled albums with images of the excavations, and have provided a mise en abyme with each and every photograph of destruction and preservation, including that form of preservation generated by their own medium. In Roberto Rossellini's film *Viaggio in Italia* (1953) the camera shows how the alienated married couple, Katherine and Alexander Joyce, witness the excavation of two Pompeian bodies lying close together. Victor Burgin alludes to this scene, which he combines with fragments of dialogue from the opening sequence of Rossellini's film, in his voiceover script for his video work *Voyage to Italy*.

Victor Burgin's first encounter with Pompeii was literary. His reading of Freud's essay on Wilhelm Jensen's *Gradiva* resulted in 1982 in a work of the same name: seven photographs each with a *subscriptio*, together forming Burgin's laconic retelling of the story told in the novel. In Jensen's story, a young archaeologist, Norbert Hanold, falls in love with a Roman relief, a "tomb memorial" of a young woman with an unusual gait. Hanold acquires a plaster cast of the relief and hangs it on the wall between his book shelves, "in just the right light." He calls the woman "Gradiva," the "moving" or "striding one." "In her," Jensen writes, "something humanly commonplace, though not in any low sense, something 'contemporary,' as it were, was physically reproduced. It is as if the artist had captured her swiftly in a clay model after life as she passed on the street, and not in a pencil sketch on a sheet of paper as in our day."[2] In *Voyage to Italy,* through movement almost at a standstill, the standstill in the movement, through transitions between fragmented Corinthian columns (like a detached film image) and through the overlapping of physical and psychical space in the uncovering and exposing of a crossing of gazes, cut and panoramically seamed, Burgin creates a photographic, panoramic, and acoustic space that layers impressions and invites us, as in a psychoanalytical transference, to isolate our phantasmatic projections, to capture them in their disjointed fragmentary forms so as to see "the retrospective chimera"[3] rise again.

In his work *Gradiva,* Burgin had directed the gazes of the deluded archaeologist and the wistful "Gradiva," or Ms. Bertgang, past one another in opposite directions, "as if the narrative, as it progresses beyond the mid-point, 'meets itself coming back' in the opposite direction."[4] Burgin puts time in the gaze, in the female and the male gaze, taking the gaze out of the coordinates of Euclidian space and into psychical space. We know

2 Wilhelm Jensen, *Gradiva. Ein pompejanisches Phantasiestück,* in Sigmund Freud, *Der Wahn und die Träume in W. Jensens, Gradiva,* ed. and intro. Bern Urban (Frankfurt am Main 1995), p. 128. Cf. also my essay "Tomorrow For Ever—Photographie als Ruine," in *Tomorrow For Ever. Architektur/Zeit/Photographie, eds.* C. Aigner, H. v. Amelunxen, W. Smerling, exh. cat. Museum Küppersmühle Sammlung Grothe and Krems Kunsthalle, (Cologne, 1999), pp. 15–25.
3 Théophile Gautier, "Arria Marcella," in idem, *La Morte amoureuse, Avatar et autres récits fantastiques* (Paris, 1981), p. 195; cf. Anthony Vidler, "Buried Alive," in idem, *The Architectural Uncanny: Essays in der Modern Unhomely* (Cambridge MA, 1992), pp. 45–57. Also Laura Mulvey, *Death 24 x a Second: Stillness and the Moving Image* (London, 2006), esp. pp. 54–67 and 104–123.
4 Victor Burgin, *Between,* (Oxford, New York, and London, 1986), p. 124.

5 Sigmund Freud, "Erinnern, Wiederholen und Durcharbeiten," *Studienausgabe* (Frankfurt am Main, 1975), p. 213. Cf. also Victor Burgin, "Paranoiac Space," in idem, *In/Different Spaces: Place and Memory in Visual Culture* (Berkeley, 1996), pp. 117–139.

from Freud that time does not count in psychical space; Freud speaks of the "timelessness of the unconscious" and of the fact that if the linear model of time gives way to any model at all, then it gives way to a cyclical model. In Freud's view, the compulsion to repeat replaces the impulse to remember, and remembering represents "the reproduction of psychological realms."[5] Burgin's treatment of the photographic and the filmic image is in this "shifted" temporality of reproduction. His photography is the crypt of cast gazes. It assimilates traces of space and releases the gaze into the time of a lasting future, as an uncovering of what has been buried. Moreover, it does this on the threshold that it itself constitutes, since in the panorama what is *now* perishes hopelessly in *what is to come* and yet repeatedly approximates to the origin.

The filmic panoramas in Burgin's work *Nietzsche's Paris* (1999–2000, on the esplanade of Dominique Perrault's Bibliothèque Nationale de France), in *Elective Affinities* (2000–2001, in the Mies van der Rohe Barcelona Pavilion), *The Little House* (2005, in Rudolph Schindler's Kings Road House), and now in *Voyage to Italy* (2006, at Pompeii) are, so to speak, "sewn" together from images, joints in the filmic sequence, made with a digital still camera, the resulting curvilinear perspectives corrected and animated in software. While in *Elective Affinities* the constant converging reference point of the gaze is the statue (by Georg Kolbe) of a woman with her arms raised to shield her face from the sun, in *Voyage to Italy* Burgin places a woman in absentia at the origin of both the photographic and the photographed gaze. In an album entitled *Principales Vues de Pompeii,* by the Neapolitan photographer Carlo Frattaci, dated 1864, and found in the archives of the Canadian Center for Architecture in Montreal, there is a picture of a woman whose clothes give her the appearance of a modernist cone, in contrast to the Corinthian columns beside her: the skirt of her dress is greatly inflated by the crinoline; over it she is clasping a pelerine tightly to her breast so that her arms and legs are concealed; her head seems small, as if representing only the tip of the cone, half of it concealed by her wide-brimmed sunhat. Resembling a geometric figure, her appearance serves merely to illustrate the spatial proportions of the forum of the basilica, skirted on both sides by twelve fragmentary Corinthian columns, and yet she embodies—as does the photograph—the fundamental question raised by the archaeologist Norbert Hanold: the question "of the nature of the physical appearance of a being who is both dead and alive, although the latter only in the witching hour of midday." The woman stood here "as the only living being alone in the hot midday stillness amidst the remains of the past fit to see, not with physical eyes, and to hear, not with corporeal ears."[6] One panorama glides through the 180 degrees of the woman's field of view, a second through the field of vision of the photographer, it is these *fields of vision* that are photographed by Burgin in Pompeii almost one and a half centuries later.

6 Jensen 1995 (see note 2), p. 161.

"Wherever the eye roams, it finds nothing but walls and sky," says Walter Benjamin, with reference to Pompeii as "the largest labyrinth, the largest maze in the world." Burgin literally turns the scene photographed by Carlo Fratacci, the ruins of the forum, into a scenario for what is for us an invisible game between desires and encounters, contacts and hallucinations. In his article, "The Ruin," of 1907, the year in which Freud wrote his *Gradiva* essay, Georg Simmel wrote that architecture was the "most sublime victory of spirit over nature," whereas the ruin, by contrast, "a sad nihilism," embodied the failure of the spirit against nature. The ruin however is the site of the origin. It is not the past character of the ruin that gives it meaning, but rather the origin, recognisable in the ruin and gathered in a becoming, that distinguishes the real meaning of the ruin. Certainly "it is a site of life from which life has departed," but above all the ruin creates "the current form of a past life, not on the basis of its contents or remains, but on the basis of its past as such." Only in the manifest demise of a building can one interpret the future for which it was determined and into which it has now obviously fallen. According to Simmel, the ruin must be seen as "the realisation of a direction laid down in the deepest layer of the existence of what is destroyed."[7] The first of Burgin's two series (Basilica I), comprising two rows of twelve frontal photographs, show the columns both before and behind the absent woman, the "midday ghost" (Jensen), in the incident dark and bright light, a filmic "shot/reverse shot," so as to inscribe a secret into what is looked at, something seen into what is invisible. It is in the tension of this opposition within the insignia of a present that the end of a becoming was accomplished and tarries until now as a becoming end. In Burgin's finite-infinite mirrorings, the photographic itself also befalls us. In its continuous movement towards lasting decline, photography, as the only promise that has ever given birth to a nihilism, draws us into the constellation of the past and the coming as past. And in the apparent stillness of the image even what is most concealed is whirled up into an event—photography as disaster, and "the disaster ruins everything, all the while leaving everything intact."[8]

If the panoramas give the impression of an extended synchronism—it was Genet who, when asked what speed was required to see what was *behind* in the *here,* recommended the rotation of an airplane propeller: "Then you would realize that things have disappeared, and we ourselves with them"—then the individual photographs mark distinct sections of time and fracture the stone horizon. It is as if Burgin had also assumed the attitude of Norbert Hanold so as to repeatedly focus on "what he had already seen or imagined" and to avoid the disappointment that she, Gradiva, was "only a silent image in front of him, a silhouette that was denied language." Burgin's second series (Basilica II), with two rows of nine photographs, revisits the perspectival hovering between seeing and being seen in the field of vision of the photographer and the

7 Georg Simmel, "Die Ruine," in idem, *Philosophische Kultur* (Berlin, 1986), pp. 118 and 124f.

8 Maurice Blanchot, *The Writing of the Disaster,* trans. Ann Smock (Lincoln NE, 1986), p. 1.

9 Freud 1975 (see note 5), p. 98.

10 Jacques Derrida, *Archive Fever: A Freudian Impression,* trans. Eric Prenowitz (Chicago and London, 1995), p. 97.

photographed person. Every next image is a "seam piece" in the film, always at the origin of the coming image and always in anticipation of what has been. *Voyage to Italy* is really "dialectics at a standstill," not continuous time, not "sequence but image, spasmodic." Analogous to the work of repression and the return of the repressed, Burgin puts the spasmodic coincidence of past and present in the place of continuous time, each gaze is seconded by another. Freud wrote that there was no better analogy for repression, by which something in the mind is at once made inaccessible and preserved, than burial of the sort to which Pompeii fell victim and from which it could emerge once more through the working of the space.[9] Gradiva in Voyage to Italy is a revenant, a Rediviva: she strides between the images and also jumps from still to moving image, from moving to still image, in the direction of the origin.

Needless to say, as a search for traces *Voyage to Italy* is also an allegory of the archive and takes into account the dual meaning of the word "impression" in the sense of imprint and impression. Jacques Derrida dedicated his lecture "Archive Fever: A Freudian Impression" to this ambiguity between concealing and conserving, and the last part of that essay deals with the delusion of the archaeologist Norbert Hanold. "Hanold suffers from archive fever."[10] In the intertextuality of the works, Burgin's *Voyage to Italy* considers the iterative becoming of the imprint as impression, the non-reproducible uniqueness of that moment when the imprint, the image with the print, is not yet separate from the impression, when no archival decision has been made.

The indexical nature of photography to itself, as an undecided witness to an immediate inscription, the striding of Gradiva whose traces in the ash the archaeologist Norbert Hanold searched for in Pompeii, and the hallucination of a present that at no point in time made an impression, that is "false at the level of perception, true at the level of time," to cite Roland Barthes, these constitute the individual moments in Burgin's work. They are linked by the "structuring absence" of a woman photographed around 1860, found in an archive of more than 50,000 photographs at the CCA. The story told in voiceover, off screen, in Burgin's video is based on two scenes from Rossellini's *Viaggio in Italia,* it links movement (a car drive to Naples) and separation (two people part, two people are uncovered in Pompeii and the ash is separated from the plaster-like bodies). We know nothing about the lady who posed for Fratacci at the scene around 1860, but of the fictions concerning Norbert Hanold and Zoe-Gradiva Bertgang and Kathy and Alex Joyce, we know that they have a happy ending.

I will end with the question which Jacques Derrida formulated at the close of his essay "Mal d'archive" "at the edge of Vesuvius" between May 22 and 28 1994: "... Who better than Gradiva, ... the Gradiva of Jensen and of Freud, could illustrate this outbidding in the *mal d'archive?*"

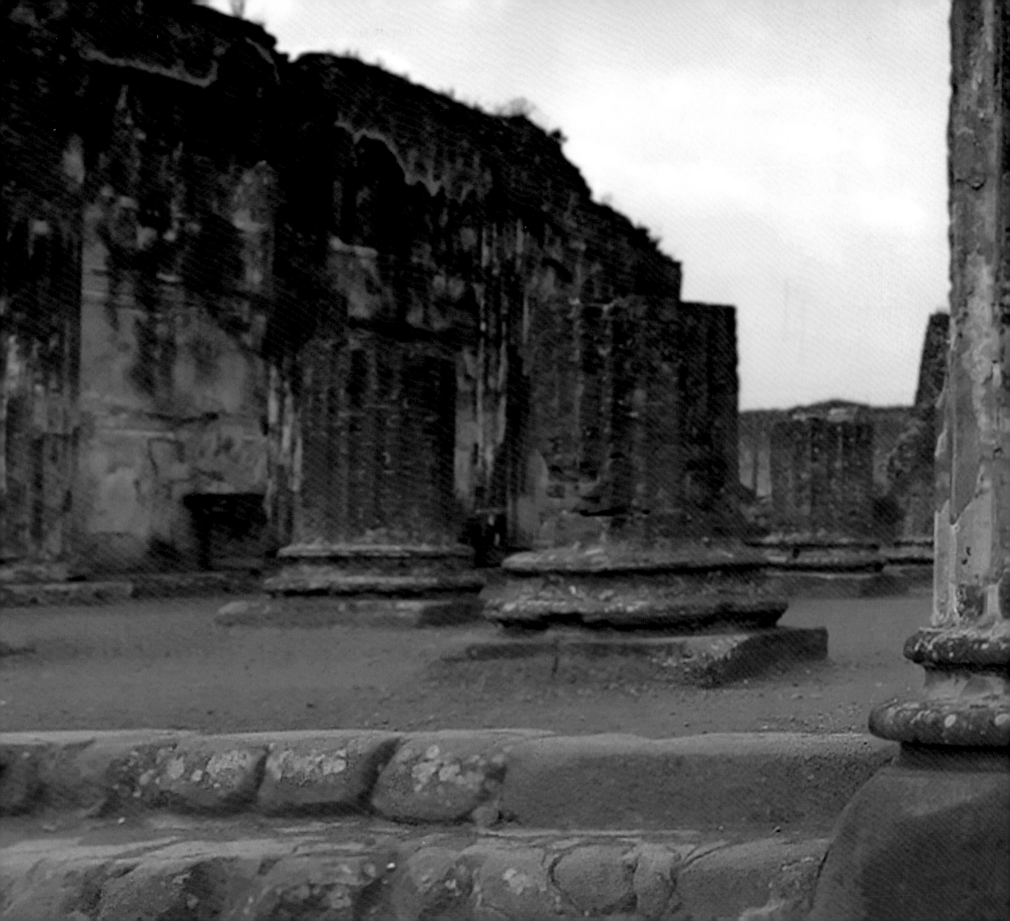

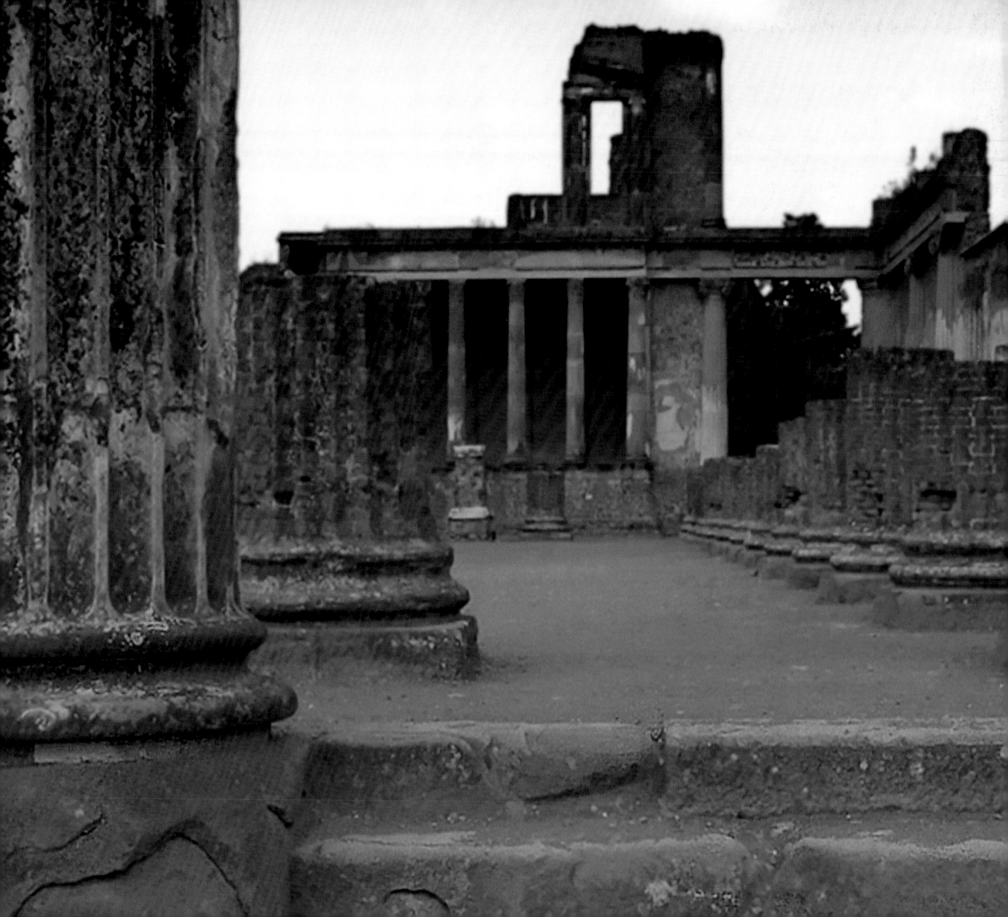

This book is published in conjunction with the exhibition
**Victor Burgin: Voyage to Italy**
Galerie Thomas Zander, Cologne
September 19 – November 23, 2006
Canadian Centre for Architecture, Montréal
December 7, 2006 – March 25, 2007

Edited by Hubertus von Amelunxen and Thomas Zander
Copyediting: Eugenia Bell
Translations: Pauline Cumbers
Graphic design: Lucy or Robert, or@either.co.uk
Typeface: Univers, Founder's Caslon
Paper: Scheufelen PhoeniXmotion Xantur
Reproductions and printing: Dr. Cantz'sche Druckerei, Ostfildern
© 2006 Hatje Cantz Verlag, Ostfildern, and authors
© 2006 for the reproduced works by Victor Burgin: the artist
© 2006 for the reproduced image on page 71 from the Canadian Centre for Architecture
*Voyage to Italy, Basilica I* and *Basilica II* were commissioned by the Canadian Centre for Architecture

# HATJE CANTZ

Published by
Hatje Cantz Verlag
Zeppelinstrasse 32
73760 Ostfildern
Germany
Tel. +49 711 4405-200
Fax +49 711 4405-220
www.hatjecantz.com

Hatje Cantz books are available internationally at selected bookstores
and from the following distribution partners:
USA/North America – D.A.P., Distributed Art Publishers, New York, www.artbook.com
UK – Art Books International, London, www.art-bks.com
Australia – Tower Books, Frenchs Forest (Sydney), www.towerbooks.com.au
France – Interart, Paris, www.interart.fr
Belgium – Exhibitions International, Leuven, www.exhibitionsinternational.be
Switzerland – Scheidegger, Affoltern am Albis, www.ava.ch

For Asia, Japan, South America, and Africa, as well as for general questions,
please contact Hatje Cantz directly at sales@hatjecantz.de, or visit our
homepage at www.hatjecantz.com for further information.

ISBN 978-3-7757-1886-8

Printed in Germany
Cover illustration: Victor Burgin *Voyage to Italy*

**HATJE CANTZ**